Contents

Right: the landscape that started it all . . . the courtyard scene taken by Niépce in 1826 and reckoned to be the world's first photograph.
Gernsheim Collection.

In this book we shall be considering landscapes in their widest sense; that includes cityscapes, a subject that has interested photographers since the earliest days. This panorama of Paris was taken in 1844 by the daguerreotype process.
Science Museum, London.

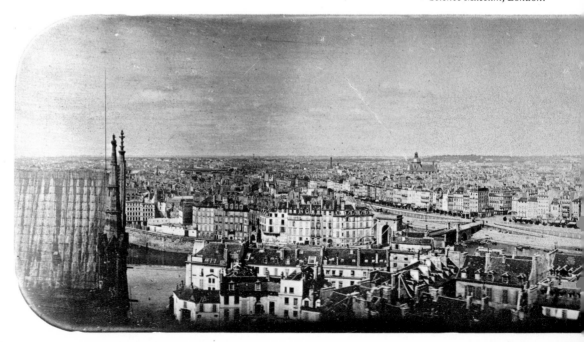

What is a landscape?

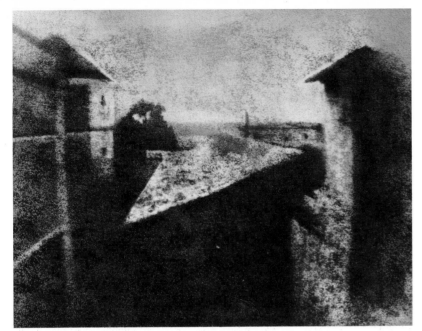

One morning in the early years of the nineteenth century, a French amateur scientist named Joseph Nicéphore Niépce began the latest in a series of experiments conducted over the previous few years. Taking a pewter plate, he coated it with bitumen of Judea and placed it in the back of a modified camera obscura, a device hitherto used by artists to project an image on to a screen as an aid to sketching. The apparatus was placed on a window-sill, pointing towards the courtyard outside, and left there all day. In the evening, the scientist removed and examined the plate. Where light had fallen on it, the bitumen had hardened and turned white; where no light had fallen, the bitumen remained soft and could be washed away with lavender oil, a treatment that resulted in a direct positive representation of the scene outside the window. The year was 1826 and Monsieur Niépce had taken what has come to be accepted as the world's first photograph. Its subject was a landscape.

Early landscape photography

Since those early days, landscape photography has flourished at both professional and amateur levels, remaining popular and surviving in spite of, rather than because of, the many different photographic processes that came and went during the following years. Niépce took the first photograph, but the first *practical* method of photography came after his death following experiments by a former partner, Louis Jacques Mandé Daguerre. His invention was the daguerreotype, many of which survive today, characterised by small, sharp images on silver plates, usually mounted in velvet-lined bookform cases. The daguerreotype process was lengthy, complicated and even a little dangerous, dealing as it did with iodine fumes at the sensitising stage and mercury fumes at the developing stage; it produced an image that was difficult to view owing

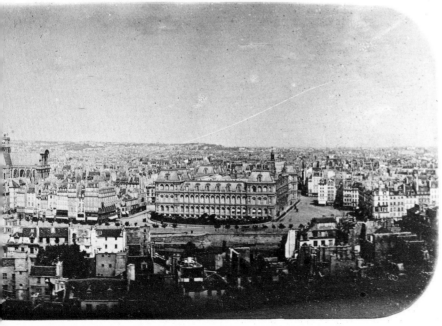

to the way the base material reflected light; it was a one-off process with no capabilities for duplicating the picture once taken; and it involved long exposure times, initially in the region of fifteen minutes. Nevertheless it captured the imagination of an entire generation and, until portraiture became possible with the design of an *f*/3.6 lens in 1840, landscapes were its prime subject.

Photography took another step forward with the introduction of the calotype, the brainchild of English country squire William Henry Fox Talbot. Fox Talbot, as he is popularly known, was very much the father of photography as we know it today, working not to find a one-off positive image of his subject, but to produce an intermediary negative from which the final picture could be taken. This he did as early as 1835, but it wasn't until he heard news of Daguerre's experiments in 1839 that he began to concentrate in earnest on his own project. Within the year, he had announced the calotype process, a system for making positive

The calotype, which followed the daguerreotype process, used a paper negative, giving a soft image that was particularly suitable for landscape photography. *Science Museum, London.*

images via paper negatives. The results showed soft-looking pictures with slightly fuzzy edges to the image that were reminiscent of charcoal drawings and thus were considered particularly suitable for images of landscapes. With a negative available for the first time, many pictures could now be produced of the same subject, a fact that led Fox Talbot to produce the first photographically illustrated book. It was called *The Pencil of Nature* and many of its illustrations were landscape subjects.

Over the following years, several different photographic processes came and went, but the next major step was the introduction of the wet-plate process by Frederick Scott Archer in 1850. This was probably one of the most unwieldy processes of all, relying on the photographer's having to make the emulsion, coating it on to a glass plate moments before use and then actually using it wet. The landscape photographer of this particular age had to be a hardy beast, capable of carrying not just a large and heavy camera into the

Two pictures by Joseph Gale, one of the last photographers to abandon the wet-plate process. *Kodak Museum.*

field, but also a portable darkroom in which to make his plates. All this equipment was usually transported on the photographer's back or by means of a darkroom on wheels that resembled a large wheelbarrow. The end products of the wet-plate process were prints made by contact with the developed plates and ambrotypes, small glass-based images made by mounting the actual negative plate on black velvet so that the emulsion reflected light to represent the highlights while the velvet, seen through the clear glass of the plate, represented the shadows.

From the wet-plate process, it was but a short step to dry plates, then on to the first rollfilms in 1885. And that's the way it stayed, right up until 1982 when Kodak introduced the disc (although even that idea had been tried a century before with the Stirn camera of 1886 in which glass plates revolved disc-fashion between exposures). Rollfilms have

With dry plates, cameras became much more portable and far more convenient for the landscape photographer. This picture was taken with a small, hand-held plate camera during the early part of this century.

become faster, smaller and of better quality so that today, even though medium- and large-format films are extensively used for their inherent quality, 35 mm has become accepted almost as a universal format for amateurs and professionals alike; and, not surprisingly, landscape photography, which survived the perils of earlier processes, is still with us and as popular as ever.

A wider definition of landscape

It doesn't take a genius to understand what made landscape photography so popular in those early days or why it remains so absorbing today. Perhaps the biggest reason is because the subject is universal. We are all surrounded by some form of landscape or another, from the rolling hills of the countryside to the urban sprawl of a city. The landscape photographer in search of a subject has only to step outside his own front door. But once there, how can he be sure that the scene before him truly constitutes a landscape? In short, what *is* a landscape?

The *Focal Encyclopedia of Photography* defines the subject thus: *A landscape is a piece of inland scenery. Besides such natural features as hills and trees, fields and hedges, a landscape may include water (river, lake, waterfall) and countryside objects forming a part of scenery, like the village church, cottages, inns, farms; also agricultural operations of various kinds, ploughing, harvesting, etc.*

That certainly sums up most people's image of the subject, but for the purposes of this book a few liberties have been taken. The traditional landscape summed up by the definition above is covered, but so too are subjects which the purist might define as townscapes, seascapes and even skyscapes. And we shall be looking at conditions that occur in connection with our particular type of landscapes: sunsets, cloud effects, rainbows, etc. It is usually considered that landscapes can be taken in different weather conditions, ranging from bright sunlight to the striking light of a stormy day. By now, it won't surprise you to learn that we are taking those conditions a few steps further too. In later pages you will learn how to use dull, overcast days to their own effect, and how to make the most of rain, snow and the soft light of dusk. Even photography at night and by moonlight is covered.

Topics covered in this book

Those are the subjects, but what of the techniques needed to capture them on film? Those are covered in detail in the coming pages. Any type of photography must begin with choosing the right equipment for the job. In this day and age, when photographic equipment is relatively inexpensive and there is such a wide selection from which to choose, it is all too easy to make the wrong choice, either through ignorance or through the temptation to buy something that looks amazing in the advertisements but turns out to be very little use in practice. To get the right equipment for the job in hand, you must first sort out your *wants* from your *needs*. You might find yourself wanting the latest piece of automated wizardry because it looks attractive and you are keen to play with all the different functions of which it is capable; but at the end of the day, you must ask yourself if you really need this particular camera, lens, or whatever. Are you going to use it to its full potential or will half its features go unused in the type of photography you are out to practise? By the same token, you mustn't buy something which is too simple. It's all too easy to buy a fully automatic camera under the mistaken impression that it will do *everything* necessary to take a good picture. Even the most sophisticated cameras need a little nudge from the photographer to give their best. A fully auto model might start you off, but you'll soon find yourself growing out of it. Between the camera with features you might need later and the one that has features you never will need, there is a fine dividing line. The very next chapter in this book tells you how to draw that line and buy the equipment you really need to be a good landscape photographer.

Read on and, having learnt how to buy the gear, you'll learn how to use it, from the basic techniques of apertures, shutter speeds and focus on the camera, through the determination of correct exposure, to the use of filters and extra lenses. The way light falls on a landscape is very important, so much so that the techniques of seeing and using light have a chapter all of their own. The basic rules of picture composition are covered after that, and towards the end of the book is a chapter on special techniques, taking you a few steps beyond the realms of straightforward landscape photography. Here you will find details that include the uses of some of the more specialist filters, the basics of multiple exposure, the effects of infrared emulsions, how to create and use soft focus, how to take panoramic landscape pictures, what camera movements are and how to use them. The same chapter also gives brief details of special darkroom techniques such as masking, solarisation and the use of texture screens.

Having learnt what you need to know about taking successful landscape pictures, what comes next? Some of the answers to that question are in the last chapter of this book. Included are details of mounting and framing your pictures for better presentation, followed by actual uses for landscape pictures: their entry into exhibitions and their sale to markets that range from private markets to calendar companies, taking in magazines and photo contests on the way.

Hopefully the information within these pages will appeal to all levels of photographer interested in using a camera outdoors to depict many different types of landscape. In places, you will find the information supplied fairly basic, and no apology is made for this. We live in an age when most potential photographers can afford extremely sophisticated cameras; the pity is that so many fail to understand what their equipment is actually doing at the moment the shutter release is pressed. If you are one of those, then read and digest the basic information on types of equipment, shutter speeds, apertures etc. in the early parts of the book. If you feel such information is beneath you, by all means skip a chapter or two.

The book has been arranged in a natural order, explaining the basics of camera and lens before you start, then leading you gradually into the general techniques of landscape photography before analysing the subject in detail and going on to more advanced and special applications. If you fail to grasp some of the technical information early in the book, or simply forget the details as you progress, a glossary of photographic terms used throughout is included at the end. The glossary also contains some of the more common photographic terms whose meanings are taken for granted throughout the book. The experienced photographer might have little use for this information; the beginner should refer to it whenever he or she is uncertain of the facts.

Anyone who has ever owned a camera must have tried landscape photography at some time, even if only to record a favourite holiday location in a simple snapshot. For many, that's as far as they ever want to go; for others, the subject becomes more fascinating, leading to the purchase of more sophisticated equipment in the hope that better pictures will result. Sadly, the opposite is more often true. Perfect equipment does not make perfect pictures. What does make good pictures is a combination of the right techniques with an eye that has been trained to search out and then portray subjects in the best possible way. This book will give you a grounding in both. If you want to start taking better landscapes, begin by turning the page . . .

The modern approach to landscape photography. The picture was shot with a red filter to darken the clouds, and then the sky and foreground were burnt in at the printing stage to heighten the effect. *John Russell.*

The value of a separate meter can be seen in a picture like this. Exposure on the side of the building was $f/16$, on the brightly-lit end of the boat it was $f/11$, on the roof of the building it was $f/8$ and in the branches of the trees it was down to $f/4$, all of which could be measured from the camera position by means of a spot meter. (The picture was actually taken with an aperture of $f/11$.)

Right: a red filter can be used to dramatise the simplest of subjects. *John Russell.*

Choosing the right equipment

Straight away, it should be emphasised that highly specialised equipment is by no means a necessity for this type of work. Through the decades, landscape photographers have produced top results with no more than a basic camera with a standard, fixed lens. Even so, certain types of camera, lens or accessory naturally give different effects, are more convenient to use, and in the end produce better results. By the same token, other types of camera, lens, etc. are *not* recommended. For the photographer looking for the most suitable equipment for any branch of photography, the choice is as wide as it is often confusing. With landscape photography specifically in mind, here are some points to consider before buying.

35 mm cameras
The most popular type of camera on today's market is undoubtedly the 35 mm single-lens reflex (SLR), used by beginners and experts alike. While such a model is eminently suitable for landscape work, it is not necessarily the preferred choice. Because of its popularity, however, we will consider it in some detail.

The biggest advantage of the SLR, whatever its format, is its ability to accept a range of different lenses and to show the exact effect of each in the viewfinder. This last advantage is still a major one, even to the landscape photographer who will not be too bothered with parallax problems, negligible at distances beyond two metres when using a standard lens. There are many models of SLR made by different manufacturers, but only a few basic types.

The fully manual single-lens reflex is something of the past these days. It is simply a camera in which the shutter and aperture are set by the user and in which there is no form of integral metering. Such a

camera is perfectly suitable for landscape work, but no modern manufacturer makes one in the 35 mm format. Many fine examples are, however, still available second-hand, and the newcomer to photography on a limited budget would do well to invest in one, rather than pay a similar price for a modern camera that might prove totally unsuitable to his needs.

Every major 35 mm SLR manufacturer today produces cameras with TTL (through-the-lens) metering, but the way it is connected to the camera controls differs with various systems. The first of these features match-needle or LED metering. This is basically a manual camera on which the shutter and aperture controls can be set by hand, but which has a system in the viewfinder that tells the user when the exposure is set correctly. This can take the form of two needles that match with one another, LEDs that light against each other, or something as simple as two-coloured LEDs that glow red when the exposure is wrong and green when it is correct.

Whatever the system, the method of use is the same. The photographer selects a shutter speed, then turns the aperture ring until the system indicates that correct exposure has been obtained. Alternatively, he can select an aperture, then turn the shutter speed dial until the correct exposure is indicated. On some of the older models of camera, the metering must be carried out with the lens actually stopped down to the working aperture; so, while measuring the exposure, the viewfinder will grow dim as the scale is turned towards the smaller openings. All modern SLRs, however, feature open-aperture metering, which means that the aperture remains wide open all the time the metering is in action, closing down only at the moment of exposure. This type of camera is perfectly suitable for landscape photography.

With priority automatic cameras, the TTL metering takes on a more sophisticated form. They break down into two types: shutter priority and

Ease of use coupled with versatility make the 35 mm single-lens reflex the most widely-used style of camera among serious photographers.

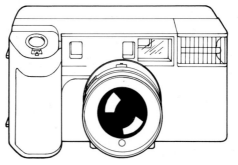

The 35 mm compact with its fixed lens and auto functions is suitable for some types of landscape, but it is not recommended to the photographer who is serious about landscapes.

The rollfilm single-lens reflex combines the advantages of the 35 mm SLR with a larger format.

aperture priority. With the former, the photographer selects a shutter speed and the camera automatically sets the correct aperture at the moment of exposure; with the latter, the photographer selects an aperture and the camera automatically sets the correct shutter speed. While most of this type are made in either shutter or aperture priority models, there are a few multi-mode cameras that offer both. Some also offer a programmed mode in which the camera selects

both shutter speed and aperture. Of the single-mode models, aperture priority is the more common.

This category of camera can also be further broken down into those that offer manual override of the automation and those that don't. Where it is applicable, the override can take several different forms. The most straightforward method is for the camera to feature normal shutter and aperture controls that can be set manually when the automation is switched out and irrespective of what the meter suggests should be set. Another method offers a button that allows the photographer to nudge the exposure to the next shutter speed or aperture up or down the scale, stopping when the desired setting is reached. Most auto SLRs also feature a control that will reset the exposure for two or four times over or under the indicated reading; many models feature an exposure lock that locks in a particular meter reading and keeps it ready to activate the same exposure, irrespective of light changes or the direction in which the camera is subsequently pointed.

Provided that this type of automatic camera has a manual override of some sort, it is suitable for landscape photography. Since the effect being created often relies on getting the depth of field right, and therefore the use of the correct aperture, an aperture priority model has advantages over its shutter priority counterpart. Most photographers who are serious about the subject agree that the best type of manual override is still that in which the automation is switched out and the shutter/aperture combinations are set by hand in the traditional way.

When a camera has no manual override, it can be said to be fully automatic, usually giving either programmed or aperture priority automation, but without the possibility of allowing the photographer to countermand what the meter suggests is the correct exposure. For reasons that we shall be coming to in later chapters, what *appears* to be the correct exposure and what actually *is* correct are often quite different in this type of photography. So, while fully auto SLRs can be used for landscapes, they are not particularly recommended.

The other type of 35 mm camera commonly available is the direct vision or non-reflex type. At the top end of the market, there are a few non-reflex 35 mm cameras that offer all the sophistication of automation and lens interchangeability found in the modern SLR, but in the main this type of camera follows the compact style that has become associated with models that are little more than super-sophisticated snapshot cameras. With a lack of reflex viewing in the viewfinder, parallax is naturally a problem, but as we've already seen it need not worry the landscape worker too much. Far more worrying is the lack of exposure control offered on most models of this type. Some offer a shutter or aperture priority system, others a programmed mode, but with the exception of those few expensive models there is little manual override to be found. Good landscapes *can* be taken with compact cameras but, again with the exception of the top-of-the-market models, the vast majority are not recommended for the person who is serious about the subject.

Before leaving 35 mm cameras, it is worth mentioning autofocus. This is something that is gaining in popularity and appears on many of the non-reflex cameras mentioned above. It is also beginning to appear on single-lens reflexes, in the form of special lenses. Some SLRs provide a focus aid in the form of viewfinder LEDs that tell the photographer which way to turn the focusing ring on the lens until the picture is sharp within a designated area, at which point a third LED lights.

Such aids and automation are useful for the photographer needing to focus in a hurry and for the man or woman whose eyesight might be poor, but for the serious photographer working in

landscape photography they offer little that cannot be had as well, or even better, by the more traditional use of a rangefinder. Autofocus is by no means a necessity, and in some cases can be a hindrance as the mechanism homes in on a part of the picture that you actually wanted to throw out of focus. If you are forced to use one of these cameras for landscape work, make sure it has a focus lock. With that, you can at least focus on one part of the subject, lock onto it and then reposition it in the viewfinder. Without the lock, the focus will change as you move the camera.

Rollfilm cameras

The vast majority of rollfilm cameras are single-lens reflexes. They offer similar advantages to their 35 mm counterparts, but with better quality from larger film formats and usually with the added advantage of interchangeable viewfinders, a facility found on only a few of the more professional 35 mm models. This serves two purposes. First, it gives the photographer the opportunity of viewing the subject either through a pentaprism viewfinder at eye-level or through a waist-level finder. The second advantage is the way exposure modes can often be switched with the viewfinder. A manual camera with the appropriate accessory viewfinder can be immediately transformed into an aperture-priority model.

Rollfilm SLRs all take 120 and/or 220 film. On that, there is a choice of format according to the model of camera or, with some makes, according to the interchangeable film back. A 6 × 4.5 cm format gives 15 shots on 120, 30 on 220; a 6 × 6 cm format gives 12 shots on 120, 24 on 220; and a 6 × 7 cm format gives 10 shots on 120, 20 on 220. Some models even add the opportunity of fitting 35 mm backs to the cameras, offering, depending on which back is in use, the chance of producing standard 24 × 36 mm negatives or a panoramic 24 × 59 mm format.

Rollfilm single-lens reflexes are particularly suitable for landscape work, especially when used with the waist-level finder. Landscape photography, perhaps more than any other type, relies heavily on picture composition. While a picture can easily be composed at eye-level, the classical lines of composition seem to stand and fall so much more clearly on the big, clear screen of a waist-level finder. When the camera offers one of the oblong, rather than square formats, and if the camera does not have an interchangeable back, the format will be arranged so that its longest side is horizontal, the shape most often associated with landscapes. If the picture demands a vertical format, such a camera must be used with an eye-level viewfinder. Without it, the photographer would be forced to stand at right angles to the desired scene and its image in the viewfinder would be upside down. If the camera features an interchangeable back, that can be rotated through 90 degrees for vertical shots and the camera still used with a waist-level finder. A minor disadvantage of using a waist-level finder is that its mechanics dictate that the image appears laterally transversed, but this has little effect on actual composition.

The same is true of the second type of rollfilm camera, the twin-lens reflex (TLR), regarded by many photographers as the ideal for landscape work. Sadly, the style has lost popularity over the years and no more than a handful of models are still made. Many second-hand TLRs are still available, however, and at remarkably low prices, considering the specifications they have to offer. The photographer interested in landscape work would do well to invest in one before they all disappear. The twin-lens reflex, as its name implies, has two lenses, one above the other. The lower lens focuses on the film in the normal way, the upper lens projects its image via a 45 degree mirror on to a hooded screen on the camera top. The format on all models is fixed at 6 × 6 cm, the only TLRs available are manual, and only one maker offers interchangeable lenses. Parallax can be a problem, but one that is minimal for reasons already discussed.

16

The twin-lens reflex is a dying breed, but one that is still favoured by many landscape workers.

A very few direct vision rollfilm cameras are also available, offering formats of up to 6 × 9 cm (eight shots on 120, sixteen on 220) and interchangeable lenses. These cameras are perfectly suited to landscape work, though it should be borne in mind that they are often expensive and aimed mainly at the specialist photographer.

Sheet-film cameras
With this section, we come to large format. While most models of this type take rollfilm backs and therefore offer the chance of shooting on 120 or 220 film, they are more often used with single sheets of film in special holders that vary in size from quarter-plate (10.8 × 8 cm), through 12.5 × 10 cm (more traditionally known as 5 × 4 in), up to 25 × 20 cm. A few of these large-format cameras are made as single-lens reflexes, but far more follow the style of the view camera. This amounts to no more than a lens panel linked to the back panel by a set of bellows. The two ends are supported on either a baseboard or a rail; in the latter case it is more often known as a monorail camera.

A monorail camera, or any technical model that is capable of movements, is a boon to the serious landscape photographer.

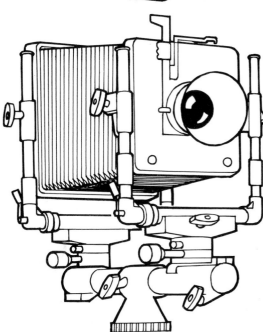

In use, the camera is fitted to a tripod and the shutter, usually built into the lens, is opened with the aperture at its widest setting. The scene is viewed on a sheet of ground glass at the back of the camera, the shutter closed and the correct exposure set. In the dark, film is loaded into its special holder and sealed with a dark slide. When needed, this holder is slotted into the back of the camera in the same plane as the ground-glass, the dark slide removed, an exposure made and the slide pushed back. The holder, along with the film, is then removed.

View cameras offer the landscape photographer several advantages over any other type of camera. The extra-large format provides superb quality compared to that obtained with rollfilm or 35 mm; the extra-large viewing screen makes picture composition a pleasure (even though the image is necessarily upside down); but perhaps most

17

important is the facility offered for camera movements. Briefly, this means that both the lens panel and the camera's back can be shifted up and down, left and right parallel to one another, or swung around at various angles, to correct and/or change perspective in a picture. Full details of how this works and the results that can be obtained are given in the chapter on special techniques.

Many a photographer, setting out to buy the best equipment for his particular choice of photography, ignores the view camera, believing it to be too professional and too expensive for his needs. Yet good examples can still be purchased second-hand for little more than the price of a modern single-lens reflex. Admittedly they are bulky and far from ideal for the man or woman who wants to spend a day walking and shooting pictures. But for the specialist, dedicated to his work, out perhaps to take one or two specific pictures at a time, the view camera has no equal.

Other cameras
The only other types of camera pertinent to our theme are those that fall either into the slightly off-beat field or into the snapshot market. Panoramic and stereo cameras can be counted in the first of these categories. Panoramic cameras produce a negative or transparency with the same depth as a traditional format but with extra width.

The amount of extra width varies with the way the camera works. Two of the most popular types are those in which the lens pivots at the time of exposure and those in which the whole camera revolves. With the former, apertures are set in the normal way and the speed at which the lens pivots determines the shutter speed. The picture is 'sprayed' on to the film through a small slit at the rear of the lens, and a picture of just under 6 cm width is produced on standard 35 mm film. With the second type of panoramic camera, the whole body revolves on a static handle as the film moves in synchronisation across the focal plane. Again a slit is used at the rear of the lens, its width

determining the effective speed, apertures being set in the normal way. These cameras are highly specialised and are made in two sizes for 35 mm or 120/220 rollfilm. Exposure can be made of anything up to a complete 360 degree circle, when the width of the image on 35 mm film is 16 cm; on rollfilm it is 38 cm. A third type of panoramic camera uses a lens designed to cover a large format, but runs a length of 120 or 220 film across its centre. The result is an image 6 × 17 cm. Shutter speeds and apertures on this type of camera are set conventionally. Panoramic cameras are specialised pieces of equipment and expensive to buy, but they are of particular use to the landscape photographer, giving a new view of the subject which often results in making something special out of a quite ordinary scene. More about their use and panoramic pictures in general in the chapter on special techniques.

Stereo cameras, using two lenses for their effect, come into the realms of specialist equipment.

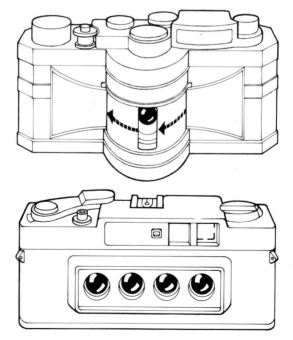

Panoramic cameras work in a variety of ways. This one has a lens that pivots at the moment of exposure.

The only production stereo camera currently available uses four lenses to achieve a three-dimensional result in the final print.

Although there are still a few models left that can be bought second-hand, the only current and commonly-available model works on a different principle and is aimed more at the snapshot market. It uses four lenses to take four slightly different pictures on half-frames of 35 mm; the three-dimensional effect is produced at special processing laboratories where the four images are combined into one with the use of a lenticular screen. This allows each eye to see a different part of the picture, thus producing the effect without the aid of special glasses, a viewer or any other apparatus. Stereo cameras, old and new, work well with the right type of landscape picture, especially one that has a good deal of foreground interest to contrast with the background.

While some 35 mm cameras could be termed snapshot models, most of this type are designed for 110, 126, or disc film. The first two films take the form of drop-in cartridges, giving formats of 17 × 13 mm and 28 × 28 mm respectively; the third type takes pictures, not on the traditional length of film travelling between two rolls, but around the circumference of a rigid disc of film that rotates one space between each exposure. Image size is 10.6 × 8 mm. These film sizes and the cameras associated with them are aimed basically at the snapshot market and are not recommended for the serious landscape worker. The exception is a couple of sophisticated miniature SLRs designed to take 110 film. In theory they should be as well-suited to landscape photography as their 35 mm counterparts, but in practice the size of the format and the limited choice of films available for it restrict their use too much for the serious photographer.

Despite the fact that some highly technical work is being done with instant-picture cameras, the majority of these models also fall into the snapshot market. Like some other models mentioned above, instant cameras can be used for landscape photography but are not necessarily recommended,

The disc (left) and the instant picture camera are not recommended for the photographer who is serious about landscape photography.

19

apart from their use for checking composition, content, exposure, etc. of a picture before committing it to normal film. The best method, then, is to use not an instant *camera*, but an instant *back* on a traditional camera that has a facility for fitting it. Medium-format SLRs and sheet-film cameras are the usual type.

Lenses

A standard lens, the type that is most often supplied with the camera, is designated as one whose focal length is approximately equivalent to the diagonal of the format it serves. On 35 mm that gives a standard lens of around 50 mm; on medium format the standard is more like 80 mm; larger and smaller formats require longer and shorter standard focal lengths respectively. The angle of view of a standard 50 mm lens on a 35 mm camera is 46 degrees, and for many landscape workers this proves perfectly adequate for the majority of subjects. Either side of the standard lens are shorter and longer focal lengths, which give wider and narrower angles of view. The former 'opens up' the picture area, allowing the inclusion of details that could not be recorded with a standard lens from the same position; the latter pulls distant objects closer, allowing the photographer to record them larger in the frame than would have been possible with a standard lens.

Using the 35 mm format as a base, **wide-angle lenses** start at 35 mm, then go on to 28 mm and 24 mm. After that, as they widen out even more to focal lengths like 16 mm and even as short as 8 mm or 6 mm, we come into the area of **fisheye lenses**. At the latter extreme wide angles, the picture is circular in shape and extremely distorted, straight lines adopting a curve and the degree of distortion growing worse towards each edge of the image. The same is less dramatically true of a fisheye lens of around 16 mm focal length, but up to this point rectilinear lenses can be produced which correct distortion, allowing a wide angle of view of around 96 degrees while keeping straight lines in the image straight. Not surprisingly, such a lens is a lot more

expensive than its fisheye counterpart. Equivalent, but more expensive, wide-angles and fisheyes are available for larger-format cameras.

At the other end of the scale are lenses whose focal lengths are longer than the standard. There are three types: long-focus, telephoto and mirror. A **long-focus lens** is simply one whose focal length is longer than the standard and which is fitted into a barrel long enough to allow it to focus on the film plane. The physical length of the lens is thus dictated by its focal length. With a **telephoto**, several elements are combined in groups to give equivalent focal lengths in shorter distances. This makes telephoto lenses more compact than straight long-focus lenses. More compact still is the **mirror lens**, which uses concave mirrors as well as ordinary lens elements to fold the light path back and forth along the barrel. Light enters from a large element in the front, is reflected off a mirror in the back, bounces back off another mirror behind the front element, and finally leaves through a hole in the centre of the rear mirror. The result is a long focal length in an extremely short, stubby lens barrel. A disadvantage is that the lenses all have small fixed apertures.

Again using 35 mm as a base, longer-than-standard focal length lenses start at around 80 mm and go on to focal lengths like 135 mm, 200 mm, 400 mm, 500 mm, 1000 mm and even as much as 1200 mm, where the angle of view would be no more than two degrees. Equivalent lenses are available for medium-format cameras, but the overall range is far smaller and the prices much higher.

Zoom lenses feature a range of focal lengths that can be changed according to the angle of view required. There are two methods of operation. On one, the focusing ring, as well as performing its normal function, also moves up and down the lens barrel, changing the focal length as it moves, in which case the lens is designated as a one-touch zoom. On the other type, the focusing ring performs only its normal function and a second

A typical range of lenses available for most 35 mm SLRs.

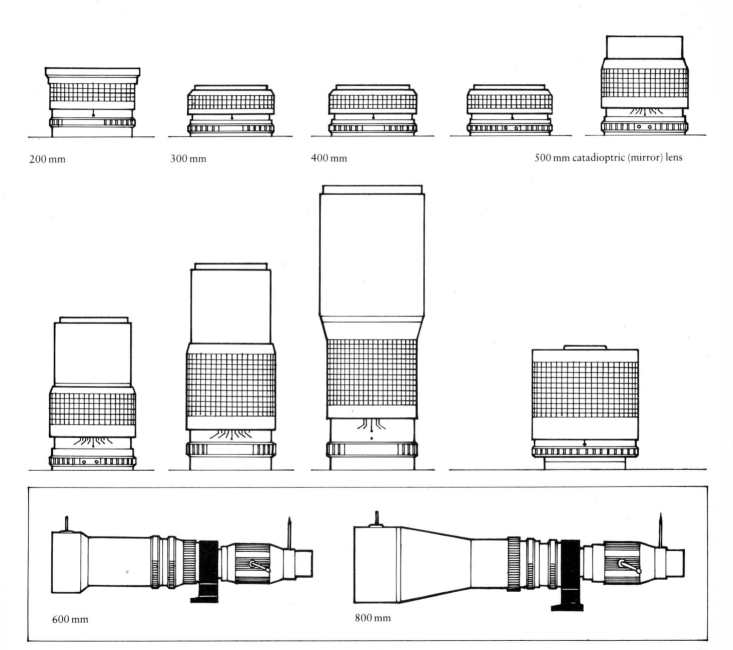

17 mm 24 mm 28 mm 35 mm 135 mm

200 mm 300 mm 400 mm 500 mm catadioptric (mirror) lens

600 mm 800 mm

21

ring is turned to change the focal length. That is a two-touch zoom. The choice is purely personal, but it is worth bearing in mind that, with a one-touch lens, unless it features some form of zoom lock, it is all too easy to inadvertently alter the focus while operating the zoom control. For that reason, some photographers prefer the two-touch to the one-touch type.

Zoom lenses come in different ranges. There are wide-angle zooms, covering a short range of focal lengths from wide-angle to standard; there are standard zooms that give an extremely useful range of focal lengths each side of the standard; and there are long-focus zooms, starting at a focal length longer than standard and going through to even longer lengths. In recent years the technology needed to produce zoom lenses has moved fast, with the result that zoom lenses are today every bit as good as fixed focal lengths when it comes to quality, and also result in ranges of focal lengths that would have seemed impossible a few years ago: lenses with ranges like 35–200 mm, 50–250 mm and 150–600 mm. Perhaps the most useful zoom lens for the landscape photographer is the 28–85 mm, found in most 35 mm lens manufacturers' catalogues. It gives a worthwhile wide-angle effect at one end of its range, passing through the standard to a short telephoto length.

A good second lens is one that, again on 35 mm, covers a range of around 85–200 mm. It is entirely possible for a landscape photographer to cover all but the most specialised or unusual subjects with, at the least, no more than a 35 mm SLR body plus 28–85 mm zoom and, for a little more versatility, the addition of an 85–200 mm zoom. Again there are zoom lenses available for medium-format cameras, but the range is very small compared to those sold for 35 mm cameras. Not surprisingly, medium-format zooms are very expensive.

Macro lenses are rarely used by the true landscape photographer, who has little need to focus extra-close to the subject. If, however, you aim to

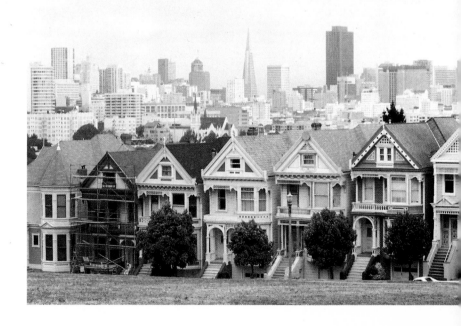

22

A standard lens from this viewpoint includes a lot of foreground and makes too little of the real point of the picture: the contrast between ancient and modern buildings in the background.

Switching to a telephoto (in this case, a 200 mm lens on 35 mm format), the foreground is excluded and perspective in the background is shortened to make the most of the subject.

look beyond the traditional forms of landscape photography to details within the landscape such as flowers, a macro lens, while by no means a necessity, is a useful addition. Basically, all the term means is that the lens has the ability to focus past the normal closest-focusing distance. It does this by means of some device that allows the lens to move further than normal from the film plane: the further the lens is from the film, the closer it focuses, though it should be remembered that at distances further than normal, moving the lens results in a certain amount of light loss that renders the marked apertures ineffective. It is necessary, then, to open up the aperture by set amounts, according to the focusing distance, something which is always detailed by the manufacturer and will be adjusted automatically by TTL metering. Macro lenses come in a wide range of focal lengths.

A **shift lens**, also known as a perspective control lens, can be of use to the highly specialised landscape photographer. This gives an effect on a 35 mm or medium-format camera similar to that obtained with camera movements on a view camera (see the chapter on special techniques). It can be shifted sideways or up and down from its normal axis, but still parallel to the film plane to correct the distortion that is inevitable under certain circumstances. Its most common use is to prevent the vertical sides of a tall building from appearing to converge towards the top: you keep the camera straight and shift the lens when the shot is taken, rather than tilting camera and lens to get the top of the building into the frame.

An **anamorphic lens** is one that has two different focal lengths, one in the vertical plane, the other in the horizontal, giving two different magnifications of the image on the same piece of film. The effect is to 'squash' the image in one plane, usually the horizontal one. When the negative so produced is enlarged through another, or the same, anamorphic turned through ninety degrees, the result is a panoramic print. The same effect can be achieved by projecting 'squashed image' slides

through the anamorphic. More details on this practice in the chapter on special techniques.

Converters

The most common type of converter is the **teleconverter**, an auxiliary lens that fits between a normal lens and the camera body and, in so doing, increases the focal length. Teleconverters are sold as independent items to work with any lens, or as specialist types that have been computed and designed to be most effective with a specific lens. The second type is undoubtedly the best and, when used with the lens for which it was designed, gives effects indistinguishable from those obtained with a straight lens of similar focal length. Use of a teleconverter results in a certain amount of light loss, something which will be detailed in the instructions and taken care of by the camera's metering if it is TTL. **Macro converters** are also available and are used in the same way, fitting between a normal lens and its camera body. With the macro converter in place, a standard lens with no in-built close-focusing capabilities can be used to shoot the subject same-size on the film. Again, use of a macro converter results in light loss.

A more unusual converter, but one which is of interest to the landscape photographer, is the **fisheye converter**. This is an auxiliary lens that screws into the filter thread on the front of a normal lens, considerably widening its angle of view. Fitted to a standard 50 mm lens on a 35 mm camera, it gives an angle of view similar to that obtained from a 16 mm lens; fitted to a 28 mm lens, it produces a full circular fisheye effect, similar to that given with a 6 mm lens. The image quality is not as high as it might be with real fisheye lenses, but considering the extremely low price of these accessories the results are perfectly acceptable. Since this converter fits to the front, rather than the rear, of the normal lens, no light loss is involved.

Film

Landscape photography is a traditional artform that has grown up with black-and-white film to

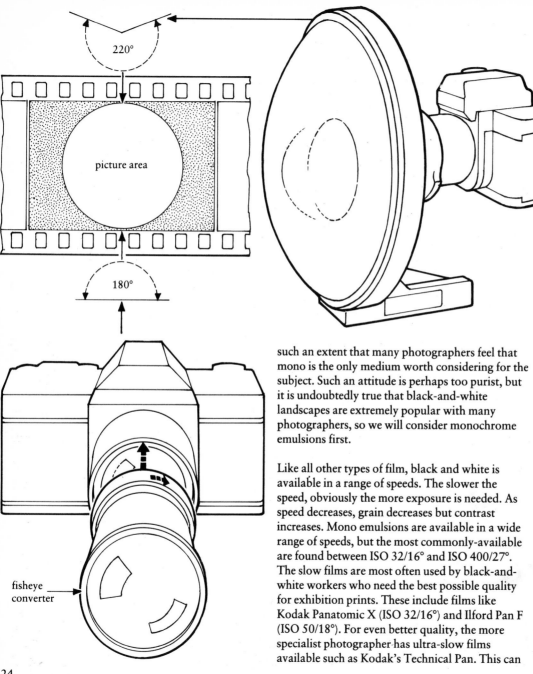

picture area

220°

180°

fisheye converter

Two methods of obtaining an ultra-wide fisheye shot: with a fisheye lens and, on a much less expensive scale, with a special converter that screws into the filter thread of a normal wide-angle lens.

such an extent that many photographers feel that mono is the only medium worth considering for the subject. Such an attitude is perhaps too purist, but it is undoubtedly true that black-and-white landscapes are extremely popular with many photographers, so we will consider monochrome emulsions first.

Like all other types of film, black and white is available in a range of speeds. The slower the speed, obviously the more exposure is needed. As speed decreases, grain decreases but contrast increases. Mono emulsions are available in a wide range of speeds, but the most commonly-available are found between ISO 32/16° and ISO 400/27°. The slow films are most often used by black-and-white workers who need the best possible quality for exhibition prints. These include films like Kodak Panatomic X (ISO 32/16°) and Ilford Pan F (ISO 50/18°). For even better quality, the more specialist photographer has ultra-slow films available such as Kodak's Technical Pan. This can

A special converter used on a 28 mm lens (on 35 mm format) is an inexpensive but highly effective way of producing this fisheye effect.

be rated as low as ISO 25/15°, when it gives exceptionally fine grain and optimum quality. It has excellent highlight and mid-tone separation but is inevitably prone to high contrast, a factor which must be borne in mind with the choice of subject and developer.

One strong disadvantage of slow films to the landscape worker is that long exposures are needed, resulting in wide apertures if the camera is hand-held and so leading to shallow depth of field.

In the middle of the speed range is a series of films rated at ISO 125/22°. These include Ilford FP4 and Kodak Plus X. Both are well-suited to the average landscape photographer, giving a fairly wide exposure and development latitude, high definition and perfectly acceptable grain when exposed and developed correctly. Highlight and mid-tone separation is excellent, and exposures allow shutter-speed/aperture combinations that make depth of field perfectly adequate in normal lighting conditions.

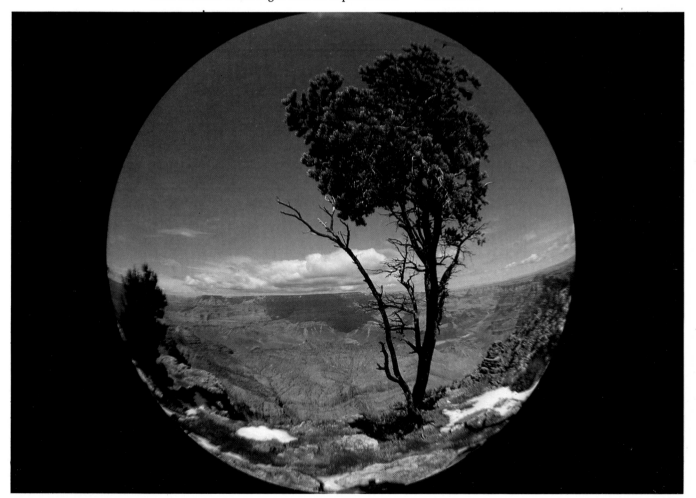

At the top end of the speed scale come the ISO 400/27° films that include Ilford HP5 and Kodak Tri-X Pan. Both exhibit good grain for films of this speed but the grain is obviously more coarse than that found in slower films. Use in landscape photography is best restricted to those occasions when the extra speed is essential and/or an extra-small aperture is needed to increase depth of field. On the other hand, there are occasions when certain special techniques are being applied and some degree of graininess is required. In these instances a high-speed film is particularly useful, not so much for its speed as for its other characteristics. And taking *that* idea to its logical conclusion, it is worth knowing that there are a few super-speed mono films, designed primarily for use in low light or when extra-small apertures are needed, that can be used specifically to enhance grain effects. These include Kodak Royal-X Pan (ISO 1250/32°) and Kodak Recording Film 2475 (speed according to development but, on average, ISO 4000/37°).

All the above films produce traditional silver-based negatives. A different chemistry, and one that gives superior results, is used in chromogenic films. In these the negative image, instead of being formed by silver, uses a silver-type emulsion that is actually bleached away during the processing, the image being formed by a colour dye at a bleach-fix stage. The processing is naturally different from that for the more conventional films; in fact, it works in the same way as the process for a standard *colour* negative.

The result is a film that can be rated as low as ISO 125/22° and as high as ISO 1600/33°, depending on development times. It is even possible to rate the film at a low speed, then switch to a high one half-way through the roll. The processing is then carried out for the higher speed so that the first negatives on the roll are, in effect, overdeveloped. The difference between chromogenic and more traditional emulsions is that overdevelopment does not increase the grain structure. If anything, it

decreases it. All the negatives on the roll can then be printed with no loss of quality in the final print. Chromogenic emulsions offer something not seen in mono film before their introduction: high speed with fine grain. So, despite the fact that processing is a little more complicated than with more normal film, they have caught on with landscape photographers. Perhaps the very best quality available to the black-and-white worker who wants a film of a decent speed in an easily handled camera is to use a 120 chromogenic film in a medium-format SLR.

Most of what has already been said regarding grain and contrast with mono films is equally true for colour, but with the latter you also have to take colour temperature into account. Colour temperature is measured in kelvins and is defined as the temperature on the absolute scale (°C + 273) to which a black body, reflecting no light, would have to be heated to give off light of the colour in question. In simple terms it means that, although the human eye does not always perceive it, different light sources are actually different colours: artificial light is more red than daylight, daylight is more blue than artificial light. The film, which does not have the powers of compensation of the human eye and brain, picks up the differences.

Colour film, then, must be balanced for different light sources. In practice, this means it is balanced either for artificial light or for daylight. Artificial-light film is further divided into emulsions balanced for Photofloods and others balanced for tungsten light. The first is known as Type A, the second as Type B. Type A is rapidly dying out in the UK, though versions are still available in the USA.

Colour film is also divided into negative and reversal stock. The first produces negatives for printing, the second yields transparencies, but reversal prints can also be made from these if required. The vast majority of colour films are balanced for daylight only. A few reversal films are balanced for tungsten light and an even smaller

number of negative films are too, although a colour cast induced in a negative by the wrong source of light at the taking stage can often be corrected at the printing stage.

The majority of colour negative films range in speed from ISO 64/19° to ISO 400/27°, the exception being Kodacolor VR 1000 which, as its name implies, is rated at ISO 1000/31°. Most reversal films are rated at speeds ranging from ISO 25/15° to ISO 400/27°, with, at the time of writing, one emulsion rated at ISO 1000/31°. A medium-speed colour film of ISO 100/21° is the usual choice when shooting negatives, and as slow a film as is practical is usually chosen when shooting transparencies. The best reversal film is generally recognised as being Kodachrome 25 (ISO 25/15°), but that can prove a little slow, despite the excellent quality that results from its speed. A reversal film of ISO 64/19° is probably the most commonly used, giving speed coupled with quality.

Because of the nature of the subject, landscape photographers should naturally use daylight-balanced colour film, be it reversal or negative. The exception is when you are out to create a specific effect with a colour cast (tungsten film in daylight gives a blue cast to everything), or when you are shooting at night and want the correct rendition of lights in your pictures.

A rather more unusual film, sometimes favoured by landscape photographers, is infrared. It is available both as a colour and as a mono emulsion, both of which rely for their effect on the fact that the film's sensitivity has been extended to record light rays beyond the red end of the spectrum and into the infrared, the first of the wavelengths at the red end invisible to the human eye. Neither of the film types has good keeping properties, and both should be stored in a freezer before and after use. The speeds of the films vary with the filtration in use. The black-and-white version can be processed in ordinary developers, although some plastic developing tanks might leak infrared light, a

problem that can be solved by wrapping the tank in aluminium foil, shiny side out. The colour film is a variation of the Ektachrome process, but must be processed in the now outdated E4 chemicals, rather than the current E6 process. You can read more about the film's applications and the results you can expect from it in the chapter on special techniques.

Another unusual and somewhat remarkable film is Polaroid's instant 35 mm. To all outward appearances, the cassette is a standard 35 mm type which can be used in any normal 35 mm camera. When the last shot has been taken, the film is rewound in the usual way, removed from the camera and placed in a small processor along with a special processing pack. The lid is closed and a handle turned to wind the film out of its cassette. After 60 seconds it is rewound and the processor opened to reveal a cassette of perfectly processed transparencies, dry and ready for mounting. The film is available in three reversal types; black-and-white continuous tone (ISO 125/22°), black-and-white high contrast (ISO 400/27°) and colour (ISO 40/17°).

Filters
Filters are used by the landscape photographer for three main reasons: to change the tones of certain subjects in relation to others in monochrome photography, to correct colour casts in colour photography, and to induce certain special effects in both mono and colour. All these techniques are examined in depth in later chapters; here we shall concern ourselves only with the *types* of filter and the systems available.

There are four main types of filter: those that screw into the lens, those that bayonet on to the lens, those that push over the lens, and those that fit into a special holder that in turn screws into the lens. Most lenses have filter threads in standard sizes, the most common of which are 49 mm, 52 mm, 55 mm and 58 mm. Those are the sizes that are found on the majority of 35 mm camera lenses. On

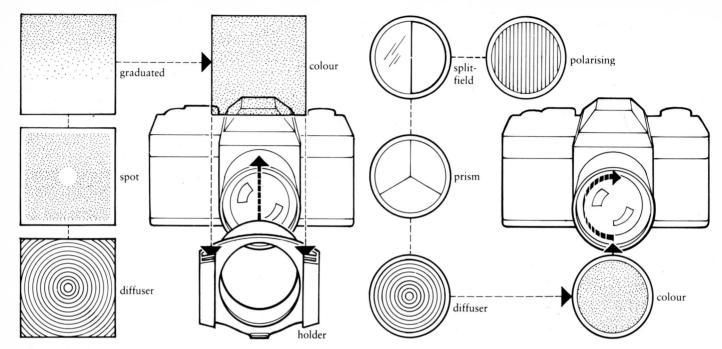

graduated

colour

spot

diffuser

holder

split-field

polarising

prism

diffuser

colour

more specialist lenses and on those on larger-format cameras, the filter threads are larger.

The first type of filter is made specifically for a certain lens size. It is circular in shape, made from glass or plastic dyed or coated to the required colour, and is held in a circular mount that screws into the lens. To fit filters of one size to lenses of another, it is necessary to employ step-up or step-down rings. The bayonet-fitting filter is similar, except that it is made for a specific make of camera that, instead of a filter thread, has a bayonet fitting designed to take its own filter. The push-on type of filter, instead of screwing *into* the filter thread, is pushed *over* the lens barrel.

The fourth type of filter is one that has gained tremendous popularity in relatively recent years and, perhaps more than anything else, is responsible for bringing filters back into their own with the average photographer. In this system, a specially-made holder screws to the front of the

lens via an adaptor ring that can be changed according to the diameter of the lens in use. One or several filters at the same time can then be slotted into the holder. Some manufacturers make two different holders for medium and large diameter lenses; other make adaptors so that filters from one system can be fitted into holders of another. The filters are usually square, although some in each range are circular, each fitting into a different slot in the holder. There are three main advantages over the older type of screw-in filter: the lack of need for step-up and step-down rings when changing from one lens to another; the fact that certain filters that rely for their effect on different positions relative to the lens can be moved up and down or left and right within the holder until exactly the right result is produced; and the lower cost in buying new filters for the system, since you are paying only for the filter itself, rather than for the filter plus individual mount.

Some lenses that have extra-wide front elements

The two most popular types of filter system. Left: square filters that slot into a holder that, in turn, screws into the lens. Right: circular filters that screw straight into the lens.

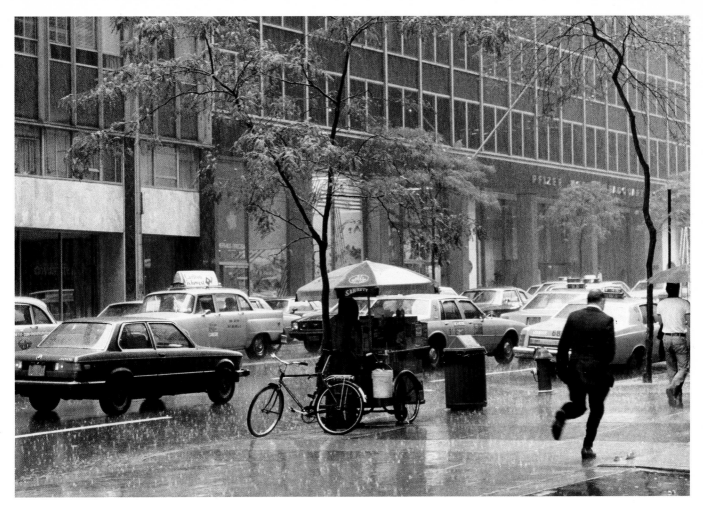

Even the worst conditions can be captured on film today. This was shot in overcast daylight and pouring rain with an exposure of ¹/₁₂₅ second at f/5.6, using Kodacolor VR1000 film, whose speed rating is ISO 1000/31°. *Kodak*.

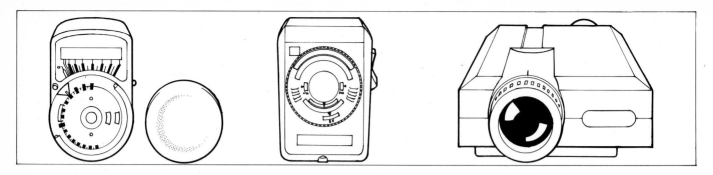

use special filters that screw into the *rear* or slot into the *centre* of the lens, rather than fitting on the front in the more normal way. These lenses are usually sold with their own sets of filters.

Meters and other accessories

In the next chapter we shall be examining the importance of correct exposure in landscape photography, and we shall see that the meter in a camera can often be fooled. Despite the fact that the majority of cameras these days have built-in metering of one kind or another, a case still exists for the use of hand meters in certain situations.

The first types of meter used selenium cells. When light falls on selenium, a small electric current is generated and this is used to deflect a needle. The brighter the light, the more the current and the greater the deflection. Meter cells made from cadmium sulphide work in a different way. They do not generate a current, but when light falls on them their resistance increases. With a small battery to produce a current, they can therefore be used to measure the intensity of light. Cadmium sulphide cells respond better in dim light than selenium cells, but they are over-sensitive to red and are sometimes slow to react, suffering from a 'memory' of previous light measurements. Other types of meter cell include silicon blue, which has a far faster response time than cadmium sulphide and does not suffer from 'memory', but which can become erratic in temperature extremes; and gallium arsenide phosphide cells, which are similar

to silicon blue cells but not as unreliable through temperature change. These latter two are most often used linked to LEDs, rather than to deflect needles.

Hand-held meters can be used to take exposure readings right up against the subject without moving the camera's position, something of particular use in certain types of landscape work. They can also be used for incident-light readings. For this, the meter is fitted with a small cone of translucent plastic that cuts down a set percentage of light and is then used to measure, not the light reflected *from* the subject, but the light falling *on* it. In use, the meter is held at the subject position and pointed back towards the camera.

Getting a reading from the principal subject in a landscape is one of the prime techniques of better landscape photography, but there are times when that principal subject might be a mile away. That's when a spotmeter – possibly the most useful type of meter for the landscape photographer – comes into its own. A spotmeter is like the reflex viewing system of an SLR with a meter built in; the difference is its extremely narrow angle of view, often no more than one degree. It can be used, therefore, to take accurate readings from small objects in the centre of a vast landscape and, as such, gives the most accurate reading of all. More about how best to use a spot meter in the next chapter.

Despite the automation built into today's cameras, a hand meter is still an advantage. Left to right: a selenium-cell meter with cone for incident-light readings; a silicon-cell type that can be used straight or as a flashmeter; and a spot-reading attachment that, when fitted to the appropriate meter, narrows the angle of acceptance to give extremely accurate readings of specific areas of the landscape.

A tripod is one of those accessories that is by no means a necessity to the landscape photographer but can be invaluable in certain circumstances. On occasions when you might be shooting with an extra-long telephoto lens, a tripod is necessary to prevent camera shake; it is often needed for night photography; and it is useful on those occasions when you want to compose a picture to perfection, then keep exactly the same composition while you fit various accessories (filters etc.) to the camera. When you choose a tripod, choose a sturdy one. Anything that moves as you adjust the camera simply defeats its own object.

Lens hoods are accessories that are often ignored by photographers, but they are of particular use for reducing flare when shooting into the light. Lens hoods should be deep and matt black inside. If the surface becomes scratched, repaint it with matt black from a model shop. Buy different diameters for different lenses. One that is correct for a standard lens will cut off the corners of a picture on a wide-angle lens; conversely, one that is correct for the wide-angle will not afford enough protection on a standard lens.

A good camera bag is essential to the landscape photographer, but don't be tempted to buy one larger than you need. Landscape photography, more than any other type, can often entail trekking across the countryside for hours on end, and a bag that was no more than moderately heavy at the start of a trip can feel like a ton weight after a few hours. So go for one that is as small as practical for your choice of kit, and preferably invest in one that is made from lightweight material with a wide strap that makes it easy on your shoulder.

For those who prefer to distribute the weight of their camera equipment more evenly, a photographer's vest can be more convenient than the traditional bag. This usually takes the form of an armless jacket, made of thin but tough material, with a heavy-duty zip up the front and with a range of different types of pocket incorporated both inside and outside. The pockets are large and padded; some are zippered, others close with touch-fastening material. Cameras, lenses, filters, film, etc. can all be carried about the person and in places that are easily accessible as and when each piece of equipment is needed. Photographers' vests are particularly useful to the landscape photographer who might have to carry a lot of equipment for several miles often just to take a single picture.

Flashguns are rarely used by the landscape photographer, although they can be useful occasionally for filling in the light in extra-dark shadows. Don't invest in anything too sophisticated if that's all you are going to use it for; instead, buy a small automatic gun that has a moderate guide number and uses a sync cord rather than a hot-shoe only attachment. Then invest another few pounds on an extension cable so that you can position the flash away from the camera when desired.

A photographer's waistcoat helps to distribute the weight of equipment when you need to carry it over long distances. As such, it is very convenient for the landscape photographer.

Motor drives and power winds are of little practical use to the landscape worker, although they have become popular in all types of photography simply as an alternative to the photographer's thumb. Although the landscape photographer has no real need for a motor drive, then, it must be admitted that a power wind can be convenient when more than one picture needs to be taken of the same subject and you don't want to ruin the carefully chosen composition by taking the camera from your eye to wind on. Count these items as luxuries: buy one if you can afford it, but not at the expense of other, more practical accessories such as filters and lens hoods.

Non-photographic accessories

Landscape photography differs from most other types in one major area: it takes place exclusively out of doors. It can also involve miles of walking to get the best picture in a particular area. Comfortable clothing, therefore, is essential. In summer months, the choice is relatively easy. Trousers and loose-fitting cotton shirts make the most sense, but stay clear of nylon or other man-made fabric that does not absorb sweat and so can become very irritating to the skin after a long walk. Cotton, by comparison, is absorbent. When choosing what you are going to wear, think also about what you have to carry. A T-shirt might feel comfortable, but remember that it has no collar, and after a few hours of walking with a camera strap rubbing against the skin on the back of your neck you might begin to wish you had worn a shirt. With that, the camera strap can rest more comfortably against the collar. Thin clothing can also give problems if you have a heavy bag to carry, as its strap begins, after a while, to cut into your shoulder. It's better, then, to wear something that will absorb and distribute the weight better. This is one place when a photographer's vest over a lightweight shirt makes a lot of sense.

Shoes should also be chosen carefully. In summer months, when you do not have to worry about the cold, you can wear almost any type, just so long as they are comfortable to walk in. In winter, rubber boots are suitable for short trips that might involve a lot of mud or even snow, but perhaps the best form of footwear is a good stout pair of walking boots. They will support your ankles, making walking easier and will grip wet surfaces better than ordinary shoes.

In cold weather you will keep warm if you wear a good-quality parka type of jacket with a quilted lining. A woollen hat is useful too if you suffer from a cold head in bad conditions. Normal gloves are next to useless, preventing intricate actions like screwing filters in place or changing film. Special mittens are available whose ends can be unfastened to reveal the wearer's fingers for as long as it takes to perform the necessary actions, but failing these an ordinary pair of woollen gloves with the thumb and fingers cut off just above each knuckle can be pressed into service. Despite the fact that half of each finger is exposed, both hands and fingers stay remarkably warm.

A compass is another non-photographic accessory of particular use to the landscape photographer who sometimes plans certain pictures well in advance of actually taking them. When making such preparations, it is essential to know from which direction the sun will be shining at particular times of the day, and that can only be ascertained when the direction faced by the subject is known. Failing a compass, and if the sun is visible even at its weakest, an ordinary watch can be used to work out direction. The method is as follows. Point the small hand of the watch at the sun, then bisect the angle between that hand and the number twelve on the dial. The direction taken by that line points south; the other three points of the compass can then be calculated accordingly.

A wide-angle lens (page 20) is particularly useful to the landscape photographer, not only allowing a wider expanse of the scene to be recorded on film, but also giving greater apparent depth to a picture. This was taken with a 28 mm lens on 35 mm format.

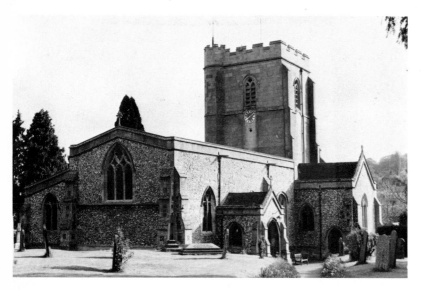

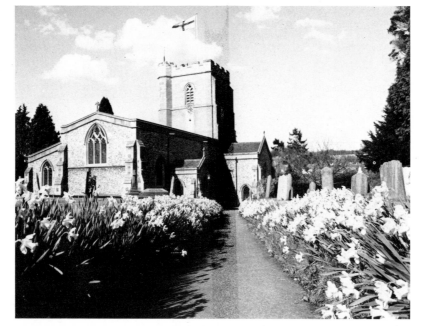

The importance of advance preparation. The picture above is a straightforward 'snapshot', taken with a standard lens on a first visit to the church. A more detailed look at the location then showed that the picture could be improved in three ways: (1) by shooting during the late afternoon when the sun shone obliquely on the front of the stonework; (2) by using a wider-angle lens and choosing a low viewpoint to emphasise the bank of daffodils leading to the church; (3) by adding an orange filter to make more of the sky. The second picture was taken by revisiting the location at the right time and prepared with the right equipment.

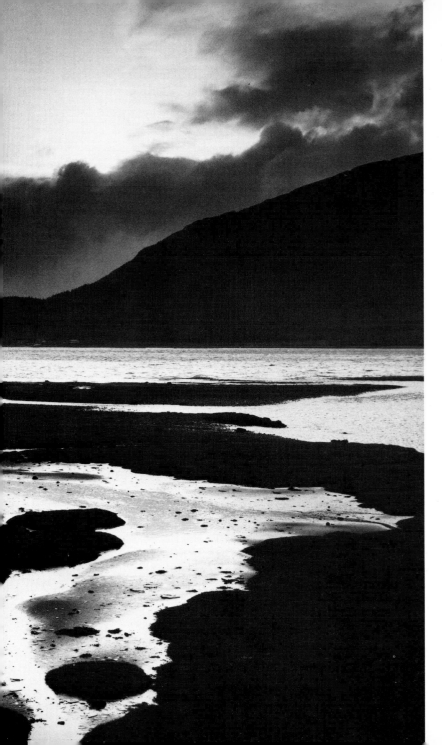

Basic techniques

Successful landscape photography relies on two prime abilities: finding the right subject and then deciding how best to shoot it. The first of these is often a matter of chance, discovering a suitable subject as you tour an area in search of pictures. The second comes down to a combination of aesthetics – selection of the best angle, time of day, weather conditions – and pure photographic techniques, involving such considerations as the choice of the most suitable lens, shutter/aperture combination, filters etc.

Advance preparation

You can't construct or 'pose' the subject of a landscape the way you can in some other forms of photography, so initially finding a suitable subject is basically a matter of luck. Nevertheless, you can give that luck a nudge in the right direction with some form of advance preparation. Certain landscapes are going to look their best at certain times of the day or in certain weather conditions, and it is a very lucky photographer who gets the combination right first time, every time. That's when advance preparation is important.

Start by touring your chosen area and doing no more than just looking at the lie of the land. Look at trees, cottages, the patterns of hedges across fields, how the sky falls into proposed picture areas. Make a frame with your fingers and thumb and hold it at arm's length, the way film directors are so often depicted doing. It might look corny, but it is a good way of previsualising the way a picture will look on a frame of film. At this stage, you are not necessarily out to take pictures. You are looking for subjects that you feel will make good pictures at a later date. Exactly when that later date will be is dictated by what you decide is the most interesting way of photographing the subject.

Take a notebook with you and, when you find a suitable subject, make a note, describing it and how to find it again. Ascertain which direction it faces and, from that, work out at what time of the day it will look the best. If the scene involves subjects that change with the time of year, work out too which month will be best for shooting. Choose the most suitable angle and lens; locate a place from which to shoot the picture. Once you have all this information noted down or carefully stored away in the back of your mind, you have then only to wait for the right conditions and, as soon as they appear, to go straight to your chosen location and shoot without any waste of time. With many landscapes, dependent as they can be on exactly the the right type of lighting, time and the light that changes every minute can be your trickiest problem. Get your subject and picture angle sorted out in advance and you will take better pictures every time. Here are three typical examples of how that theory might work in practice.

Subject 1. A small, south-facing cottage in the curve of a country lane and partly obscured by heavy foliage from a tree standing a little way in front.
Preparation. The worst time to photograph this subject would be around noon in the middle of summer. At that time, the sun would be high overhead and slightly in front of the cottage. The lighting would be flat and shadows practically non-existent. Also, the leaves from the tree would be covering part of the subject. One solution to *that* problem would be to move closer to the cottage, using a wide-angle lens so that the subject still filled the viewfinder but the branches were now effectively moved away to make a frame around the edge of the picture. This might, however, prove impractical through lack of a suitable lens or because the tree is just too close to the cottage. The subject might, then, be better shot in winter months when the tree would be bare and the cottage could be seen through its branches, an effect that can make an interesting composition. In winter the sun would be lower in the sky, but with the cottage

facing south it would still give flat frontal lighting to the scene around noon. Shooting later or earlier in the day would ensure that the light came more from one side, and side-lighting would reveal texture in the cottage walls.
Action. Take the picture on a sunny day in winter, early spring or late autumn, shooting in the morning or late afternoon.

Subject 2. A strange-shaped tree, standing at the top of a hill.
Preparation. A subject like this might be photographed in different ways for different effects. If your object is to record no more than the tree itself, covered in leaves, it would be best photographed in spring when the leaves are younger and greener than later in the year, or in autumn when the leaves have turned to gold. Frontal lighting should be avoided, so a camera angle should be chosen that allows the sun to shine on the subject from an angle. For a different effect, it might be an idea to photograph the tree bare of leaves as a dramatic silhouette against the sky. Your best time of year, then, would be winter, early spring or late autumn, all times that produce good cloud formations and when the branches are bare, enhancing the silhouette. Particularly dramatic clouds occur on those occasions when the sky clears quickly after rain, so that would be a good time to bear in mind. The choice of a wide-angle lens would exaggerate perspective as you moved closer and therefore give the shot more drama. Yet another way to shoot this particular subject would be again as a silhouette, but this time against a setting sun. For that, the longest lens possible should be used to make the sun large in the frame, coupling this with a choice of shooting position that included the whole tree in the frame. The chosen position would have to face west.
Action. For a record shot of the tree, shoot early or late in the day in spring or autumn. For a more dramatic interpretation, shoot in the winter with a wide-angle lens on a day when the sky is interesting or with a long focal length lens as the sun sets.

Subject 3. A landscape that relies for its effect on cloud formations.

Preparation. When shooting in mono, you would need to prepare yourself with the right filters. In colour, unless you were out to put a special effect on to the sky area, they would not be as important. Cloud formations are usually more interesting in spring and autumn than in summer. In winter they can be dramatic, but their effect does not necessarily rely on a contrast between the white clouds and the blue sky, and it is that contrast that filters work on, not the blacks and greys that you are more likely to see at this time of year. Shooting into the light is inadvisable, unless you are after a specific sun-behind-the-clouds type of effect. For wide expanses of interesting sky, it is better to shoot at right-angles to the sun. So choose a position and time of day that facilitate that. Preferably shoot in the early morning or late afternoon.

Action. Visit your location on a suitable day in spring or autumn, early or late in the day, equipped with the right filters.

These three subjects, it should be emphasised, are only examples. They are not meant to tell you exactly how you *must* shoot them, but are used instead as a guide to training yourself to think ahead and prepare for a subject before the actual shooting session.

The wisdom of advance preparation cannot be emphasised enough in landscape photography and, to that end, it is a good idea to spend some time preparing a calendar of climatic conditions that can be expected throughout a typical year in a particular area. Despite the vagaries of the weather in certain parts of the world, it can be remarkably consistent month by month from one year to the next, and such a calendar can be very useful to remind you of what might be expected a few months hence. The changes that take place during the course of a year might seem obvious when they are upon you, but they often prove difficult to recall or predict in advance. Naturally it takes a

year to prepare a calendar like this, but twelve months can seem very short in the life of a landscape photographer watching the seasons change. And once it has been produced the calendar will stand for many years to come. It will of course differ with different countries and even in different parts of a single country. As an example, on page 38 is one that was prepared for the south-east of England.

Shutter speeds

Once you have chosen your subject and selected the best angle from which to photograph it, you must move into the basic techniques of recording an image on film. With that, we move from the aesthetics of landscape photography and on to the technical side. Your camera, irrespective of its format or the focal length of lens in use, has three main controls to consider: the focusing, the shutter speed and the aperture. Each is subtly linked with the other two and all three need to be considered together. Of the three, though, shutter speed and aperture are linked the most directly, giving the basis for correct exposure, perhaps the most vital ingredient in any successful picture. But they each have other uses as well.

First the basics. The shutter controls the amount of time that light is allowed to reach the film. On most cameras the shutter speeds include settings from 1 second to $1/1000$ second, though on many models there are speeds on either side of these as well, from many seconds to as short as $1/4000$ second. The shutter speeds available run in geometric progression; that is to say, each speed is exactly twice its neighbour on one side and half its neighbour on the other. So a typical shutter-speed range might run in eleven stages that look like this: 1, $1/2$, $1/4$, $1/8$, $1/15$, $1/30$, $1/60$, $1/125$, $1/250$, $1/500$, $1/1000$. (The jumps from $1/8$ second to $1/15$ second and from $1/60$ second to $1/125$ second do not fall accurately in the progression, but the differences are negligible and have been set to make the scale more manageable. Without it, the speeds above $1/8$ would have to be $1/16$, $1/32$, $1/64$, $1/128$, etc.) To save space,

Month	Conditions	Comments
January	Snow. Mist and fog. Sun shining through the mist. Skies mainly overcast, but sometimes bright blue without clouds. Trees bare.	A good time for snow pictures and early morning shots of sun and mist.
February	Rain. Snow cleared away. Bright but cold. Sun for only a few hours a day when it appears. Mostly dull. Occasionally a sudden dramatic sunset – low light level. Mild frost. Trees bare.	Bad time for photography, apart from occasional bright days. Very cold.
March	Mild frost. First signs of spring. Occasional days with sun all day, but still very cold. Heavy falls of rain that clear into dramatic skies. Leaves begin to appear on trees towards end of month. First flowers appear.	Good time for typical winter shots – bare trees against dramatic skies. Mid-to-late afternoon produces traditional winter light.
April	Sun begins to shine in a clear blue sky. Equal mix of warm and cold days. Blossom appears on some trees. On others the first leaves appear. Some trees are still bare. By the end of the month, blossom and leaves are seen in equal amounts.	First chance to take spring pictures. Shoot blossoms against blue skies. Leaves are light green and very photogenic.
May	Most flowers are out. Trees are all green. Usually a week of very hot weather. Good skies. Some rain. Occasional storms.	Good time for cloud formations – white clouds are sharply defined against the blue sky. Be ready to shoot storm pictures at a moment's notice.
June	Sunny. Hot. Storms. Sudden showers of rain followed quickly by sun give good skies and the chance of a rainbow. Often sunny in the morning and evening, with dull weather in the middle of the day.	First opportunities to shoot in the evenings when the weather and the light are often at their best.
July	Can be very hot, but sometimes dull. Scenery lush, leaves turning a darker green. Sun high in the sky for most of the day. Skies are pale blue with few clouds. Tends to be misty towards the horizon – a condition that is often cleared by rain.	Shoot only in the early morning or late evening when the light is best. Beware of mist softening the picture. Scenery is almost *too* lush.
August	Hot. Sun high in sky. Early-morning heat mists. Skies clear blue. Towards the end of the month, some leaves begin to yellow.	Best time for photography is early morning or evening.
September	Autumn sunshine. Nights draw in. Dark early, but still warm. Light mist early morning. Some fog and rain. Still quite warm. Leaves begin to brown.	Good for taking bad-weather pictures in relatively warm conditions. Ideal time for night photography – dark early, but still warm.
October	Some bright sun. Rain, fog and mist. Most leaves turn completely brown during the month.	The ideal month for autumn photography – leaves turning, sun still shining.
November	Damp, misty, very little sunshine. Usually overcast all day. All leaves have turned and started to fall. Rain and wind finally strip the trees in a couple of days.	Not recommended for landscape photography.
December	Cold. Very changeable. Sometimes dull, sometimes bright all day. High winds. Frost in the morning. Snow often by the end of the month.	A suitable time for combining snow with winter sunshine. Shoot as soon as the sun appears after a fresh fall of snow.

Different shutter speeds record movement in different ways. The first picture was taken at $1/30$ second, the second picture at $1/1000$ second.

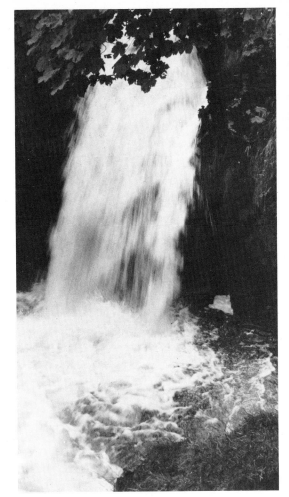

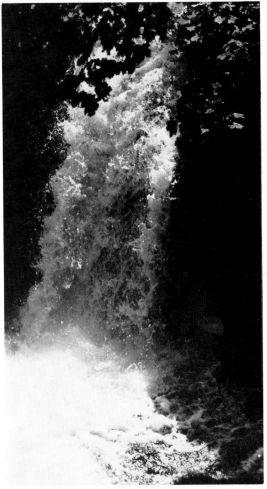

these speeds are designated on shutter speed dials as 1, 2, 4, 8, 15, 30, 60, 125, 250, 500, 1000.

Apart from its use in helping to achieve correct exposure, the shutter is used to control the way moving objects appear in the picture and also to ensure that the picture is not ruined by camera shake. The faster the shutter speed. the more the action is frozen and the less chance there will be of camera shake. The speed of the subject is not as

important to the landscape worker as it would be to, say, an action photographer who might use a fast shutter speed to 'freeze' the action of a racing car and so make it appear stationary in the final picture, or who might use a lower speed to blur the speeding car against a sharp background, giving a more impressionistic view of the subject. The landscape photographer rarely encounters conditions that call for these techniques, except perhaps when photographing subjects such as

fast-moving rivers or waterfalls. For these, a fast shutter speed might be used to record the water as frozen droplets, or a slow speed used to allow a controlled amount of blur in the subject, resulting in water that looks like soft, fluffy cotton-wool.

In landscape photography, then, the shutter speed is used primarily for two purposes: to prevent camera shake and to adjust exposure according to the chosen aperture. The minimum speed setting at which you can safely hand-hold a camera varies with the lens in use. The longer the lens, the faster the required shutter speed. As a general rule, applied to the 35 mm format, you can reckon that the minimum speed you should use is the reciprocal of the lens's focal length. So for a standard 35 mm lens, the minimum speed should be $\frac{1}{50}$ second or, to take that to its nearest practical setting, $\frac{1}{60}$ second. Likewise, a 200 mm lens needs a minimum speed of $\frac{1}{250}$ second; a 500 mm lens, $\frac{1}{500}$ second. At the wide-angle end of the focal length scale, you can use slower speeds. A 24 mm lens, for instance, could be hand-held at $\frac{1}{30}$ second. Remember the speeds quoted above are *minimum* hand-holdable speeds. In practice, most photographers take at least one speed faster than the recommended one as their minimum. Hence a 35 mm camera with a standard lens is used, when practical, at a speed no slower than $\frac{1}{125}$ second. Of course, most rules are made to be broken and it *is* possible to hand-hold a camera at speeds several times slower than the recommended minimum. This is something that will be covered later, in the section on night photography. Until you are familiar with these specialised techniques it is best to stick to the recommendations above.

The aperture
Between the elements of a camera lens there is a circular diaphragm, made up of thin metal leaves that open and close to control the amount of light reaching the film. For consistent results, specific widths of opening are designated by a range of numbers universal to all lenses. These numbers are derived from dividing the focal length of the lens by

the diameter of the opening, and they are known as *f*-stops. Taking as a starting point a 50 mm aperture on a 50 mm lens, dividing one by the other gives an *f*-stop of *f*/1. The obvious next step is to halve the diameter of the aperture, dividing 50 mm by 25 mm to give *f*/2. Halving the diameter again, dividing 50 mm by 12.5 mm we get *f*/4; dividing 50 mm by 6.25 mm we get *f*/8, and so on.

Now, although we have a natural progression of figures (1, 2, 4, 8) we don't have a fine enough control over exposure, since halving or doubling the diameter of a circle actually decreases or increases its area by four. Going from one of these *f*-stops to the next, then, would mean multiplying or dividing the previous exposure by four, which is too much for effective control. So a series of half-stops are used, meaning that the aperture scale should read more like 1, 1.4, 2, 2.8, 4, 5.6, 8 and so on. In practice, on a standard lens, most apertures start at around *f*/1.4 and run through to *f*/16 or *f*/22. On other than standard lenses, both wide-angle and telephoto, the widest aperture will be smaller.

Given these basic facts, it doesn't take a mathematical genius to see that the lower the number of the *f*-stop, the wider the aperture, while the higher numbers give smaller stops. It is also pretty obvious that going from one stop to the next effectively halves or doubles the amount of light coming through the opening: more light as you progress down the scale to the low numbers, and less light as you travel up the scale to the high numbers.

The aperture and shutter speed, therefore, can be directly linked. Opening up the aperture by one stop, and thereby doubling the exposure, can be compensated for by moving the shutter-speed dial to the next stop faster and effectively halving the exposure. Conversely, closing down the aperture by one *f*-stop means moving to one shutter speed slower. For example, an exposure of $\frac{1}{125}$ second at *f*/8 lets exactly the same amount of light through to

A small aperture and use of the hyperfocal distance (page 44) allow both foreground and background to be rendered sharply.

the film as an exposure of ⅟₆₀ second at *f*/11 or ⅟₃₀ at *f*/16. Or, travelling the other way along the scale, the same exposure can be obtained by using ⅟₂₅₀ second at *f*/5.6, ⅟₅₀₀ second at *f*/4 or ⅟₁₀₀₀ second at *f*/2.8. Different apertures, therefore, can be used to compensate for any chosen shutter speed. Or the two can be juggled to find the best combination for any given situation. As light levels drop, you must find the most practical aperture that will still allow a hand-holdable shutter speed unless the camera is supported in some way. As

light levels grow brighter, you must find a combination that gives short exposures from a combination of small apertures and fast shutter speeds.

But the aperture has another use. It is also involved in the way a camera is focused. Since that technique dictates the use of wide or small apertures according to the effect required, so the shutter speeds must be used to compensate to give the correct exposure. The technique in question is the

control of depth of field, and that is something we come to in our next section.

Focusing

The way you focus your camera lens can make or break the picture. It can be adjusted so that everything is in sharp focus from the foreground to infinity; a subject can be isolated against a blurred background; a sharp background can be contrasted with a blurred foreground. It all depends on the way you use the focusing control, the aperture in use, and even the choice of lens.

In general, to achieve sharp focus, the closer the subject is to the lens, the further the lens must be from the film; the further the subject is from the lens, the less the distance between lens and film. When the distance between the lens and the film is the same as the lens's focal length, then the lens is focused at infinity. On a standard lens, for all practical purposes, that means anything over 10 metres. Focusing is achieved by shifting the lens bodily backwards and forwards in its mount, or by moving only individual elements within the lens. Either way it means turning a ring on its barrel, noting the point at which it is focused on a scale around the circumference or watching its effect in a reflex viewfinder.

A standard lens is normally designed to focus no closer than around 50 cm. After that, the distance the lens would have to move away from the film would be too great to be practical. To focus closer than this distance, the camera should preferably have interchangeable lenses. That way, extension tubes or bellows can be added between the lens and the camera body for closer focusing. Alternatively, close-up lenses can be used. These are one-element supplementary lenses that can be fixed to the front of a normal lens, reducing its focal length and allowing closer focusing.

In normal use the amount of a picture that is in focus at any one time is dictated by the depth of field, which is the zone of acceptable sharpness

each side of the point of principal focus. For example, with the lens focused at 3 metres, everything between 2 metres and 8 metres might be sharp enough to be considered also in focus. That zone of 6 metres is the depth of field. It is dependent on three factors: the aperture in use, the subject distance and the focal length of the lens.

The larger the aperture, the smaller the depth of field. If, for example, a 50 mm lens is focused at 4 metres, the zone of sharp focus when $f/16$ is in use would be from just under 2 metres right out to infinity; at $f/8$, it would be only 2.5 metres to 7.5 metres; at $f/2.8$, it would be no more than a few centimetres each side of the set distance.

The further the subject from the camera, the greater the depth of field. Example: with a 50 mm lens set to $f/5.6$ and focused on 1.5 metres, the zone of sharp focus would be from 1.3 metres to 1.75 metres, a depth of field of only 45 cm; the same lens at the same aperture focused at 10 metres would give a zone of sharp focus from 5 metres to infinity.

The longer the focal length, the smaller the apparent depth of field. The word *apparent* is used because depth of field is not, strictly speaking, totally reliant on focal length. A long-focus lens fills the frame with a distant subject, giving a smaller depth of field than would be evident if the same subject was photographed with a wider lens from the same viewpoint. If the viewpoint was changed so that the same subject filled the frame with the wider lens, the very fact that the subject-to-lens distance was now shorter would mean that the depth of field would also be smaller. It is, however, equally true that the longer the focal length, the greater the aperture diameter at a particular f-stop. For example, the diameter of $f/8$ on a 200 mm lens is four times the diameter of $f/8$ on a 50 mm lens. Hence depth of field really is smaller.

Depth of field can be observed through the viewfinder with a single-lens reflex that has a depth-of-field preview button. A modern SLR

A wide aperture reduces depth of field, forcing you to focus on either the foreground (left) or the background (right).

views the subject and focuses at its widest aperture, closing down to the required stop only at the moment of exposure. The preview button stops the lens down manually so that its effect can be seen in the viewfinder. On non-reflex cameras, you must use the depth-of-field scale which is usually inscribed on the lens barrel. (It's usually there on most reflexes too if you want to use it, or if the camera does not feature a preview button.) The scale shows a series of *f*-stops radiating in each

direction from the lens's focusing point. To use it, the lens is focused in the normal way and then the aperture in use is read on the scale against the distance mark on the focusing ring to show exactly how much on either side of the focused point is actually in focus.

This brings us to hyperfocal distance. First the theory. When a lens is focused at infinity, the depth of field at a particular aperture extends from

43

infinity to a certain distance in front of the camera. That nearest point of sharp focus is the hyperfocal distance for that lens at that aperture. If the aperture is kept constant and the lens is set to its hyperfocal distance, everything will be sharp from half the hyperfocal distance to infinity. Once again, an example will make things clear. With a 50 mm lens set at *f*/16 and focused at infinity, the depth-of-field scale will tell you that subjects from 5 metres away will actually be in focus. Refocus the lens at 5 metres and the depth-of-field scale will now indicate that everything from 2.5 metres to infinity will be in focus. In practice, there is an even easier way of setting the hyperfocal distance, provided your lens has a depth-of-field scale. First determine the aperture you wish to use; then, when focusing, set infinity against that aperture on the depth-of-field scale, rather than against the conventional focusing mark. That way, you will get maximum depth of field every time. Remember, though, to change the focus setting each time you change the aperture.

The landscape photographer is invariably dealing with subjects at infinity, and a lot of the time is also looking towards getting as much as possible of the foreground into sharp focus. So the technique of using hyperfocal distances is one of the most useful and should soon become second nature, along with operation of the shutter and aperture settings.

Lens use
We have already seen, in the previous chapter, the different types of lens available. Here we will look more at their actual uses. It is undoubtedly worth repeating that the lens the landscape photographer will find the most use for is nothing more than the standard. Very often pictures that at first appear to require the use of different focal lengths can, on second thoughts, be taken just as easily by a change of viewpoint, rather than a change of lens.

Many photographers, when choosing a second lens, seem to go immediately for a medium telephoto or its zoom equivalent, but for the

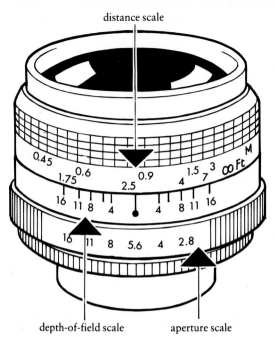

distance scale

depth-of-field scale

aperture scale

A depth-of-field scale is engraved on the lens barrel of many lenses. It tells you how much of the picture is in focus at various set apertures.

landscape worker a wide-angle lens can be of far more use. A good first choice, if you are not already using a zoom that includes this focal length, is a 28 mm for 35 mm cameras or its equivalent for larger formats. This gives a wide enough angle of view to make its effect apparent, but not so wide as to make the scene look distorted or unnatural. A wide-angle lens allows you to include more at the edges and the top and bottom of your picture than would otherwise be possible with a standard from the same viewpoint, and the shorter the focal length the wider the angle, allowing more and more of the subject matter into the frame. Wide-angle lenses, used with a little imagination, can make the most ordinary of landscapes look impressive. Not only do they stretch the outer perimeters of the picture area, they also extend the depth of the picture, making an object which might appear in the middle distance when shot with a standard lens seem much further away. Also, for reasons already explained, they affect depth of field so that subjects can be made to appear sharp all the way from only

a few metres in front of the camera right out to infinity. A beach, for instance, that is strewn with rocks can be photographed with relatively small boulders filling the foreground sharply to contrast with others in the middle and far distance.

When we actually look at a landscape we don't usually take it in from a single viewpoint as the camera does. Instead, with a brief movement of the head, we look at it from several viewpoints, our brain putting all the information gathered together to give an overall, and extremely wide-angle, view of the scene before us. That's just one of the reasons why the single, narrow viewpoint that the camera captures is often so disappointing in the final picture. A wide-angle lens, then, goes some way to correcting this, including more of what you actually saw at the time of taking the picture and giving the impression of a far more faithful rendering of the original scene.

Another use for a wide-angle lens is to include more of a subject when conditions at the time of taking make it impossible to shift your own viewpoint sufficiently. Take as an example a picturesque cottage surrounded by a high wall with a small gate. You might have two choices with a standard lens: stand at the gate and photograph only part of the cottage, or move back to a position where the entire cottage would be in the frame, but the wall is obscuring it. With a wide-angle lens, you could photograph the cottage from the gate, excluding the wall and opening up the field of view enough to get all of the building into the frame. And the wider the lens, the closer you could stand.

Rectilinear wide-angle lenses allow you to get close to your subject without image distortion, but those that have not been so corrected give a different effect, and the difference can be exploited when appropriate. The full fisheye lens gives a circular picture, but one with a focal length of around 16 mm on a 35 mm format might not immediately show its distorting effects until you start to tilt the camera. With such a lens fitted and with the camera tilted, straight lines begin to curve at the centre until the sky resembles part of a giant sphere with the horizon wrapping itself around the lower section.

Longer-than-standard focal length lenses, of course, give exactly the opposite effect. They close down the angle of view, allowing you to exclude unwanted detail at the edges. A good choice for the landscape worker contemplating his first telephoto is an 80–200 mm zoom on the 35 mm format. Within that range is found just about everything required for conventional shooting. Beyond, into the longer focal lengths, lenses are difficult to hand-hold with normal-speed films and have little practical use in the greater proportion of landscape photography.

Again, a telephoto lens can help correct the way we *think* we see things, as opposed to the way we actually see them. We have seen how it is possible to believe the overall width of a scene is greater than it really is, but given different conditions the exact opposite can also be true. Take for instance a tree on a distant hill. You look at it and you feel you would like to photograph it. While you are concentrating on the tree, your brain ignores all the peripheral detail that your eyes are actually seeing, but the camera lens isn't so easily fooled. Hence, when you take your picture, the tree you thought was going to fill the frame appears about half the size you expected. The natural solution is to move closer. If for some reason you can't (perhaps there is a river in the way), you can use a longer focal length lens to bring the subject closer and so fill the frame the way you originally envisaged it. The way a telephoto lens brings distant objects closer is particularly useful when shooting sunrises, sunsets or even the moon – subjects which you cannot actually approach. The telephoto lens can give a result impossible with a standard, showing a huge sun or moon suspended over what appears to be an otherwise natural scene. More about this technique in the chapter on types of landscape.

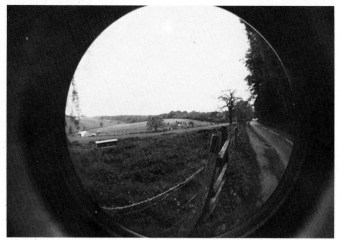

6 mm lens

16 mm lens

28 mm lens

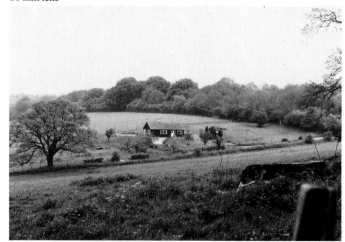

50 mm lens

Eight pictures taken on a
35 mm camera from exactly
the same viewpoint, with
lenses from 6 mm to
1000 mm, showing how
magnification changes with
focal length.

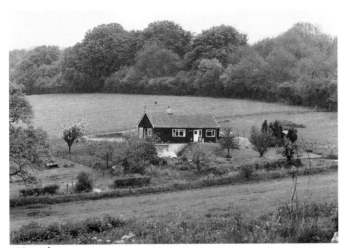
100 mm lens

200 mm lens

400 mm lens

1000 mm lens

Shot with a 16 mm lens on 35 mm format. A standard lens used from the same spot would have included only part of the cottage. Stepping back to include more would have caused the cottage to be obscured by a high wall. In such situations, a super-wide-angle lens is invaluable.

Telephoto lenses can also be used to play tricks with depth of field. If you are shooting some detail within a landscape, such as a flower against the sun, you can use a telephoto to take your picture from a decent distance, while giving a depth of field similar to that obtained by shooting with a standard lens much closer, a practice that might have resulted in distortion. Hence the subject can be rendered correctly on film and isolated against a blurred background at the same time.

Lenses of different focal lengths can also be used to control the apparent perspective in a picture. Contrary to popular belief, perspective doesn't change with the focal length of a lens, but rather with the distance the objects are from the camera. To prove that, look at a landscape picture taken with a standard lens. The relationship between various objects at the sides of the picture and fairly close to the camera will look normal. But take a look at the relationship between other objects in the centre of the picture and hence a lot further

from the camera. They will appear more cramped. Now, if a lens of a longer focal length is used from the same viewpoint, those objects in the centre of the picture can be brought forward to fill the frame, and they bring with them their relevant perspective. Hence, pictures taken with a long-focal-length lens have a more condensed perspective between foreground and background than would be the case if the same picture had been taken with a standard lens from a closer viewpoint. As you might expect, exactly the opposite is true of wide-angle lenses. Thus, if you move closer to your subject with a lens of a wider focal length than the standard, the perspective opens up.

These rules of perspective can be used to control the relationship between foreground and background objects according to the focal length of the lens in use. To prove that, try photographing the same scene with lenses of different focal lengths, each time changing the camera position so that one particular foreground object remains the

If a fisheye lens is not of a rectilinear design, dramatic distortions are introduced when the camera is tilted.

same image size in the viewfinder. As you move further away from that object, each time fitting a longer focal length of lens, the background subjects appear to get closer to the foreground object.

Exposure

With so much automation in today's cameras, can't correct exposure of all pictures be taken for granted? Many photographers buy an automatic camera in the full expectation that it will measure and set precisely the correct exposure for each and every subject it shoots. The truth is that most pictures contain large areas of widely different brightness levels, each of which would require a different exposure for correct rendition. The meter built into most cameras (or indeed hand-held meters used at the subject position) can only take an average reading of the scene, and that's the one it sets on the camera. The exception is the spot meter or a camera that has a spot-metering facility in its automation, each of which takes its reading from small parts of the overall scene.

Take, as an example, a landscape with a couple of large tree trunks framing the foreground, a white cottage in the middle distance and a large expanse of blue sky full of white clouds. Shooting on black-and-white film, with the exposure adjusted for correct rendition of the sky, the clouds will stand out clearly but the cottage and trees will be underexposed to show no more than a silhouette. With exposure adjusted for the cottage, the clouds will be wiped out by overexposure to show a clear, white sky and the trees will be underexposed to make black shapes in the foreground. (Actually the clouds could be put back in this landscape by filtration, more of which later.) With exposure adjusted for the trees, detail will be seen for the first time in the trunks and branches, but the house and the sky will be wiped out by overexposure.

So which is the correct exposure? The answer is that any one of them could be correct, depending on the effect you require. You can decide that for yourself, but the camera cannot. In all probability,

28 mm lens

50 mm lens

100 mm lens

200 mm lens

As focal lengths are changed, magnifications of foreground and background also change, giving a different sense of perspective with each lens. This set of pictures was taken with lenses from 28 mm to 200 mm on 35 mm format, the camera position being changed each time to keep the signpost the same image size in the viewfinder. Notice how the background gets closer as the focal length gets longer and the camera position moves further away from the main subject.

in this particular example, you would be looking for correct rendition of the cottage, but the camera's meter has no way of knowing this; unless it is working in a spot-metering mode it will take an average reading of the whole scene. If there is a lot of sky in the picture, that will influence the reading and the exposure that the meter sets. The result is a picture in which the sky might have a slight tone in it, but the rest of the scene is underexposed, giving a drab result. Conversely, the meter might be

influenced by a lot of shadow areas in the foreground, resulting in overexposure of the general scene.

To correct that, you must meter and then expose for the principal subject, rather than for the scene in general. If, in this case, you have decided the principal subject of the picture is to be the cottage, you must find the correct exposure for that and set it manually on your camera, ignoring what the meter tries to tell you is 'correct' for the scene in general. That's why a camera with manual override is preferable for landscape photography. If yours doesn't have this facility you must find another way of adjusting the exposure, maybe by the use of a control that allows you to give one or two stops more or less on the camera's reading or, failing that, by manipulating the film-speed setting. (Twice the film speed will give you one stop less exposure, four times the speed will give you two stops less; half the film speed gives one stop more, a quarter the film speed gives you two stops more.)

Finding the correct exposure isn't always as easy as it sounds. The ideal way is to take your camera or hand meter right up to the subject in question and take a reading from a position that excludes all else. If your distance from the principal subject does not allow that, you can use a spot meter from the camera position or take a reading from some other object nearby that appears to have the same tone as your principal subject and is facing in the same direction relative to the light. If none of these things is possible, try taking a reading from the camera position but with the meter or camera tilted to exclude the sky. This will give a more accurate reading of the general scene than one that has been influenced too much by the sky, but it might still be incorrect for the actual principal subject, depending on its tone. Nevertheless, it will still give a better exposure for the principal *part of the landscape* that you are trying to photograph, and a little intelligent bracketing at this stage should produce the correct exposure within a few frames of film.

Everything that has been said so far refers to direct meter reading, that is when the meter is pointed towards the subject to read light reflected from it. This is the way the vast majority of hand-held meters work in their normal mode, and the way all TTL camera meters operate. Another way of metering is by the incident-light method. Rather than read reflected light, an incident-light reading measures the light actually falling on the subject. For this, first fit a baffle to the meter's cell to reduce its sensitivity; then, instead of aiming the meter at the subject from the camera position, hold it at the subject position and pointed back towards the camera. The baffles are sold with, or as accessories to, many hand meters. At least one manufacturer sells a baffle that screws into the filter thread of a camera lens, allowing you to use a TTL metering camera in the incident-light mode.

A landscape photographer unable to approach the principal subject for accurate metering can use an incident-light meter at the camera position but pointed back, away from the subject. This gathers light from a 180-degree angle of view and gives an average reading for the whole scene, but one which, unlike that obtained from a direct reading, allows for constant density in all highlights. This is something that is particularly useful for colour work.

Perhaps the most accurate way of using an incident-light meter is by the 'duplex' method. This involves taking two readings, one with the meter facing towards the camera and the other with the meter (still with the baffle attached) pointed at the place within the subject on which the strongest amount of light is falling. An average of the two readings is then taken as the correct exposure. This method is particularly useful when shooting strongly backlit scenes in which some detail needs to be recorded in the foreground.

Filter use
Probably the biggest use for filters in landscape photography is with black-and-white film, where

they are used to separate certain colours that might otherwise record on the mono emulsion as similar tones of grey. To understand how they do that, it is necessary first to learn a little of why filters work. The reason the world looks green when you look through a green filter is because the filter transmits mostly light of its own colour, while absorbing the other colours that go to make up white light; it especially absorbs light of a complementary colour to that of the filter. When the filter is fitted to a camera lens, therefore, objects of the filter's colour are better exposed than the rest and objects of the complementary colour receive the least exposure of all. If the filter in use is green, objects of that colour appear darker on the negative and hence lighter on a print made from it. By the same token, red objects appear darker. (If we are being strictly accurate, green's complementary colour is magenta, but the effect works as well on colours close in wavelength to the complementary.) From this, it can be seen that there is a general rule of thumb that allows you to predict the effect of each filter: *a filter lightens its own colour and darkens the complementary.*

Perhaps the most common use of filters for the landscape worker is to put back clouds in a black-and-white picture that overexposure has wiped out. Following our rule of thumb, it can be seen that if a yellow filter is fitted it will darken the blue of the sky, causing white clouds to stand out better by contrast. It also helps to reduce the distant haze often seen in landscapes or over an expanse of sea. A yellow filter gives the scene a fairly normal look, one approaching that seen by the eye; fitting an orange filter accentuates the effect, making the sky more dramatic and reducing distant haze even more; a red filter completely exaggerates the effect, turning the blue sky practically black, making clouds stand out starkly by comparison and giving a storm-like appearance. Filters of different colours can equally be used to separate other tones in a picture. A green filter, for instance, might be used to lighten leaves on a tree that threaten to register as a similar tone of grey to the branches.

52

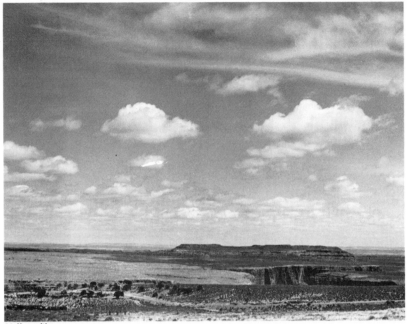

Yellow filter

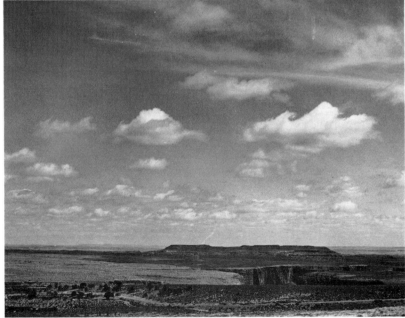

Orange filter

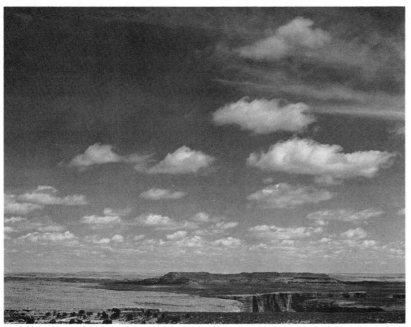
Red filter

Filters for mono photography are most often associated with their effect on the sky. Without filtration, this scene showed hardly any clouds on a straight print. Shot through yellow, orange and red filters, the blue of the sky gets darker, showing the white clouds better by comparison.

Mostly, filters adhere strictly to this rule of thumb about lightening and darkening the appropriate colours, but there is one example where the effect appears to work in reverse. This is when using a red filter on green foliage. According to the filter law, the green should reproduce much darker than normal in the final print; in fact the opposite is true, owing to a peculiarity known as the Wood Effect. In general, green objects reflect light of their own colour and absorb other colours, which is why they appear green. Plants and leaves look green because they contain a chemical called chlorophyll; despite the fact that it is green, this has the unusual property of reflecting a lot of light at the red end of the spectrum (and, indeed, infrared too). So although plants appear green to the eye, they are actually reflecting a lot of red light, a fact that the film picks up. When the camera is fitted with a red filter, it treats the plants and leaves the way it would red subjects. Hence they appear lighter in tone, rather than darker.

Of course, when filters absorb light they not only affect colour, they also cut down the intensity of light that is transmitted. So using filters means increasing exposure. Unfortunately, meters are more sensitive to some colours than to others, so you cannot rely on your TTL system to adjust the exposure automatically. Instead, you must take your reading without the filter in place, then increase the exposure by a prescribed amount. The various amounts by which you must increase the exposure are known as filter factors: these are supplied by the manufacturer with each filter. If a filter has a factor of ×2, it means increasing exposure by one stop; a ×3 needs one-and-a-half more stops; a ×4 needs two more stops; etc. This is another reason why a camera with manual override is preferable for landscape work. Without one, you must make the necessary adjustments by other methods, mentioned previously in the section on exposure.

Filters are also used for colour photography. Those above, primarily designed for black-and-white work, can be used to give an overall cast to a picture for certain special effects (orange or red filters with sunsets for instance) but in general their density is too strong for use with colour materials. Filters designed specifically for colour films are much paler and generally used to correct colour casts. Those of particular interest to the landscape worker include the following.

1 UV filters are practically colourless and are used only to filter out the ultraviolet light that causes the slight blue haze seen across wide expanses of sea or land.
2 A skylight filter is light pink in colour and reduces the blue cast that is induced by wide expanses of blue sky in fine weather.
3 The 81 series of filters contains six types of varying strengths, the most popular being the 81A, 81B and 81C. They are straw-coloured and used for warming up the picture's tones in certain conditions – such as cloudy or rainy weather – that sometimes give a blue cast. In fine weather, shadow

53

Filters can be used for more
than cloud effects. In the
first picture (left), the green
leaves and red rocks register
as a similar tone of grey.
With a green filter fitted
(right), the leaves are
lightened and so record
better against the
background.

54

areas sometimes take on a blue cast from the sky and the 81 series can be used to correct this too.

4 The 82A is a light-blue filter that can be used to correct the warm cast evident when shooting early in the morning or late afternoon to early evening. However, this very cast can be the most attractive part of a picture shot at these times, so the 82A is by no means an essential for the landscape worker.

5 The 85B filter is orange and is used for converting Type B tungsten-balanced film to daylight use, making it possible for landscape photographers to shoot with artificial light colour film when necessary. The 85 performs a similar task for the little-used Type A film balanced for Photofloods.

Two other filters of use to the landscape photographer, whether working in black-and-white or colour, are the polarising filter and the neutral-density filter. To understand how a polarising filter works, let's look very briefly at the nature of light itself. Imagine light rays as being a series of long, thin cylinders. Within these cylinders, light rays vibrate back and forth in random planes. When the vibrations are restricted to one plane only, the light is said to be polarised. Polarisation occurs naturally in light reflected from non-metallic surfaces such as glass or water. A blue sky is also a major source of polarised light since it is made up from reflections of the sun off particles in the atmosphere, although when its light strikes any object it again splits up into normal, random-vibrating rays.

Light can also be polarised by filters. If such a filter is pointed at a source of polarised light and the filter is rotated, there must come a point when it cancels out the light that is vibrating in the same and only plane as those from the source, at which point the filter is absorbing all the polarised light. It can therefore be used to darken a blue sky (made up of polarised light) without affecting the landscape beneath it (lit by the sky, but reflecting normal light). A polarising filter will also allow you to photograph through water, e.g. to give a clearer rendition of objects on the bottom of a river bed (lit by normal light) without being hindered by reflections from the surface (made up of polarised light).

If a landscape is wet after a shower of rain, a polarising filter will cut down reflections from the water droplets that dilute the colour, giving a far more saturated look to the colours of the scene. The degree of polarisation varies with the angle of the camera to the surface being photographed. It is at its height when viewed from around 30–40 degrees. Polarisation of light in the sky is at its height at a similar angle from the sun.

Neutral-density filters are varying shades of grey and are used specifically to absorb light and therefore lengthen exposure times. They can be of use to the landscape photographer who wants to use a wide aperture for its depth-of-field effects at a time when the light would normally be too bright even at the fastest shutter speed. They can also be used to increase shutter speeds to several seconds in strong daylight for certain effects such as the blurring of moving water. Neutral-density filters come in a range of densities, designated either by a filter factor relating to exposure or by a density factor relating to the percentage of light each transmits. Hence a filter designated as ND50 would transmit 50 per cent of the light that strikes it, necessitating double the exposure: the equivalent of a $\times 2$ filter factor. The filters can be combined for extra-long exposures; the method of calculating the required exposure is by adding the density factors involved or multiplying the filter factors.

If you do attempt extra-long exposures with several of these filters, however, remember that reciprocity failure is also going to play its part, meaning you will have to expose for even longer than the combined filter factors dictate. Trial and error, with some bracketing, will give you the result you require, but as a starting point try opening up one extra stop for exposures of 1 second, two stops for

exposures of between 1 and 10 seconds, and three stops for exposures of up to 100 seconds.

All the examples mentioned above are filters in the true sense of the word, in that they actually reduce or filter out certain elements of light. There is, however, another group of filters, most of which would better be termed optical devices: they don't filter the light, they alter it to give various special effects such as producing star-shaped flares from brightly-lit areas or multiplying the image a number of times on the same frame. These are dealt with more fully in the chapter on special techniques.

Here a polarising filter has been used, darkening the sky to a shade far deeper than would ever be seen naturally and at the same time killing reflections in the snow so that it records much whiter than usual. *Frank Peeters*.

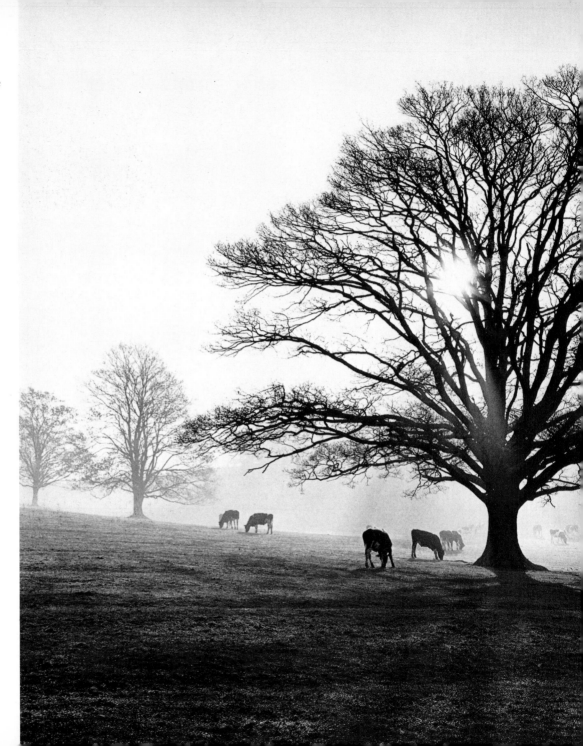

Back-lighting (sometimes called contre-jour) provides probably the best conditions for the landscape worker. *John Russell.*

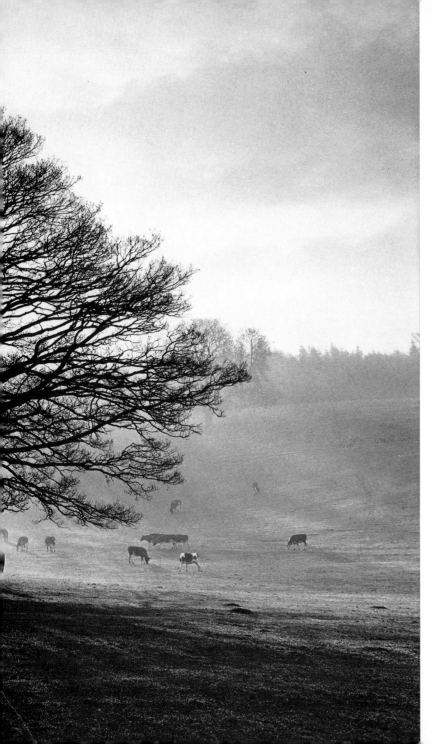

Using the light

Without light, there could be no photography. The very word photography comes from the Greek words *photos* and *graphos*, and means 'drawing with light'. It is the single most important element in any picture, because of which it is too often taken for granted; all very well if you want nothing more than snapshots, but if you are taking any form of photography seriously, you must learn to recognise different types of light and to predict how each will affect your subject. Unlike some types of photography such as portraiture and still life, where the lighting can be totally under your control, landscape work relies on what's available at the time. So choosing the right light is often more a case of choosing the right moment or time of day.

Types of light

Let us first define what we mean by two of the terms that will be used throughout this chapter: intensity and contrast. Intensity is merely the *level* of light present in a scene. It can vary from the brilliance of a clear, sunny day, when exposures on an average-speed film will involve small apertures and fast shutter speeds, to the dull light of a sky with heavy cloud cover, when exposures will need to be longer, meaning wider apertures and/or slower shutter speeds. Light intensity also varies with the time of day, being at its height around noon and at its lowest, for all practical purposes, in the dusk before sunrise or after sunset. Naturally, it is at its *very* lowest at night. The intensity of light on a landscape need not affect the picture itself, since different exposures can be used to compensate for the varying levels. However, many of the factors that govern intensity also have their own effect on contrast as well, and that *is* something that affects the picture.

In its simplest terms, contrast is the difference between the lightest and the darkest areas of a

scene. When the difference is wide, the resulting picture will exhibit high contrast; when the difference is narrow, the contrast is low. Contrast relies on several different factors. As we shall see later, clouds play one of the most important roles in its control, but it is also affected by different surfaces in the landscape. If they vary in their powers of reflection, some high and some low, the contrast level will be increased. Large expanses of flat land or those that are surrounded by water tend to exhibit a lower-than-average contrast. Direction of light is another factor. Back-lighting produces a wide tonal range from both the light source and the shadow areas it creates, thus exhibiting a high contrast; side-lighting, to a smaller extent, produces the same result.

Colour in the subject also affects the apparent contrast in a scene. If the hues of various objects are at opposite ends of the spectrum, the contrast under constant lighting will appear to be wider than it actually is. Conversely, subjects whose colours are close together in the spectrum will result in a picture that appears to lack contrast. This subject is dealt with more fully later.

Quality of light

In landscape photography you have only one light: the sun. It can be diffused by cloud; bounced from natural reflectors such as trees, buildings, or water; filtered and coloured by the atmosphere at different times of the day; and the direction from which it falls on your subject is constantly changing. But when all is said and done, there is only one main light with which to work.

To understand something of the way it affects your subject, think of the sun as a light in a studio. When such a light source is directed from a small, polished reflector, the effect is harsh with bright highlights and sharp-edged shadows bordering dark, empty areas. If that same light is bounced into a wider reflector or shone through some form of diffuser, three things happen: the actual light source becomes larger, the intensity of the light

1

2

60

3

The direction and quality of different types of light can give very different looks to a subject.

1 With the sun overhead at noon, the lighting is dull and flat.

2 In the early morning, the sun is low and, shining from the side, throws the angles of the building into sharp relief.

3 The peculiar light that comes just before a storm gives objects an almost luminescent quality.

falls, and the contrast is lowered. Now the subject is more evenly lit with softer shadows and a much smaller brightness ratio between those shadows and their adjacent highlights.

It is exactly the same with the sun outdoors. On a day when the sun is shining from a clear blue sky, it behaves like a spotlight in a studio. Compared to the overall size of the scene before you, the sun is extremely small. But it is bright and it is harsh. The result is brightly-lit highlights and deep shadows. If a cloud moves in front of the sun, you have an effect similar to hanging a diffuser in front of a studio light. The cloud itself now becomes the light source. The overall intensity of the light falls, contrast is lowered and shadows become softer. When there is total cloud cover from horizon to horizon, the whole sky becomes the light source. Pictures taken in these conditions show an extremely low overall contrast and practically no shadows at all. Taking this particular line of thinking to its logical conclusion, you come to the

point when the cloud actually surrounds you, when you are at a high enough altitude to be actually shooting in the clouds or when mist engulfs the landscape before you. Contrast and light intensity are then at their lowest, a situation that can be exploited for its own sake, as we shall discover later in the chapter on unusual conditions.

As well as being diffused, natural light can also be reflected and with similar results. The sky itself is a reflector, its blue colour being the result of the sunlight reflecting off dust particles in the air. Shooting in the direct light of the sun you might not notice that, but move into the shadows on a bright day and colour pictures will take on a pronounced blue cast from the reflected light of the overall sky, rather than the direct light of the sun itself. (The cast can be corrected by filters – see the previous chapter.) Clouds can act as reflectors as well as diffusers. A day when the sun is shining through gaps in a cloudy sky or when there is a bank of clouds along the horizon will give a lower contrast to the light. And there are other reflectors all around you in the landscape itself: trees, lakes, the sea, even the ground itself, all giving different degrees of reflection and helping to alter the light. Just as with diffusion, reflected light gets dimmer and less contrasty as the size of the reflector increases.

Between the hardest light and the softest, there are of course an infinite number of levels of intensity and contrast, all controlled by diffusion and reflection of the sun. For the sake of ease, we will look at three points along the way and examine how each affects the subject. Call these points hard, semi-soft and soft.

Hard lighting is useful for isolating part of your subject against other, much darker areas. This is especially so when the lighting is from the side, since front lighting would illuminate the shadows behind your subject, destroying its sense of isolation. With hard lighting, shadows are not something to avoid; instead they should be used as

a definite part of the composition. Hard lighting from direct sunlight at the correct angle can also be used to highlight texture. Again when the angle is correct, its reflection from glossy surfaces such as bright paintwork or water makes the subject glisten in a way it never will under any other lighting conditions. Colours appear totally saturated.

Semi-soft light is more useful to the landscape photographer than hard lighting. It gives more latitude, allowing some degree of error in direction of lighting, and at the same time creates enough shadow areas to give the subject texture and shape. On the other hand, any shadows that are thrown are lighter in tone, giving a better ratio between light and dark areas that is kinder to the latitude of most films. Colours appear more diluted than with hard light.

Completely soft lighting gives a lower contrast between highlights and shadows and the colours of a picture become totally muted. Angle is important. When it is from the front, soft lighting can show much greater detail in a subject than the harder varieties, whose shadows tend to obliterate it. When the sky is completely overcast and contrast is at its lowest, conditions are rarely suitable for landscape photography. The exception is if this lack of contrast is exactly what the photographer is after for a low-key effect – for instance, when a gap in an otherwise overcast sky allows the sun to shine through to highlight one small area of the overall scene. The contrast between that area and the rest of the landscape can result in a tremendously atmospheric picture. By the same token, a high-key scene can be very bright but the picture will have low contrast because the tones represented are close together. In that instance, it is often a good idea to introduce some dark area which, however small, brings back the sense of contrast and prevents the picture from appearing totally flat.

Direction of light
As the earth revolves, the sun appears to travel across the sky each day from east to west. How high it appears in the sky depends on where in the world you are taking your pictures. During the course of the year, the sun's apparent east-west movement takes place at the same time as another apparent movement north and south. In effect, it 'travels' no further north and south than 23½ degrees each side of the equator. Anywhere between these two latitudes, there are times of the year when the sun really is overhead; anywhere else in the world you see the sun, even at its height, from an angle to the south in the northern hemisphere and to the north in the southern hemisphere. Despite this, the sun at midday at the height of summer in the UK or most parts of North America will give roughly the effect of being directly overhead. Further north, the effect is reduced as the angle from which the sun shines begins to be more acute even at the height of summer, the effect being exaggerated the further north you travel. In winter, the sun in these areas will *always* be seen from a low angle. Similar conditions hold true for equivalent latitudes south of the equator, and are exaggerated the further south you travel during the course of their own summers and winters.

So the direction of light depends on three factors: where in the world you are taking your picture, the direction in which you point your camera, and the time of day or year. According to those factors, the landscape might be lit from the front, from the side, from the rear, or from overhead, as well as from an infinite number of angles between each of these four basic positions. Each gives its own particular effect. Direction of light can be used to isolate or emphasise certain aspects of a scene and to suppress others. The way light falls on a subject can also change its apparent shape and texture. Here is how each type of light will affect your subject.

Front lighting
A subject is front-lit when the sun is behind the photographer, thus hitting the front of any objects in the landscape facing you. The lighting is flat and grows progressively flatter as the sun approaches

Strong side-lighting shows contrasts and reveals textures in your chosen subject. *Frank Peeters.*

the horizon, illuminating the subject square-on rather than at an angle from above. Detail is revealed in the subject as the light shines directly on to it and into any crevices it contains. Texture is practically non-existent. If part of the subject is highly reflective (white paintwork on the side of a cottage, for example), either its detail will be washed out by the greater exposure needed for the rest of the subject or, if exposure is adjusted for the reflective surface itself, other areas of the picture will suffer from underexposure.

Front lighting destroys form. Solid objects look two-dimensional, almost like cardboard cut-outs pinned against the background of the landscape. Shadows are thrown directly behind each object in the picture, doing little to help the appearance of depth, and there is hardly any difference between the lightest and darkest areas of the picture. The light can, however, be used to make glossy surfaces glitter if needed, or to create the effect mentioned above with a highly reflective surface. Unless you really want to use the light for one of these effects, front lighting is not recommended for landscape photography.

Side-lighting

As soon as the light falls from one side, rather than straight on to the subject, the picture improves dramatically. Immediately, shadows begin to form and texture is revealed in surfaces facing you. The greater the angle between you, the photographer, and the sun, the more pronounced its effect, until it reaches its height when the sun is at ninety degrees to the camera and falling directly on to the side of the subject.

Shadows begin to play an important role in composition now. Subjects can be photographed brightly-lit from the side and with the front in shadow. Objects can be shot illuminated against the dark shadow of others behind. The more the light moves to the side the more three-dimensional the subject begins to appear, as opposed to the flat look of a front-lit scene. If the subject is curved,

Dull weather produces low
contrast, but even that can
be turned to advantage if
one small area of bright
illumination can be
contrasted with an
otherwise low-key picture.

As the sun sinks in the sky,
the colour temperature
tends towards the red end
of the scale, suffusing the
subject with a warm glow.

side-lighting gives a subtle gradation between the shadow and the highlight areas, emphasising shape and form.

The lower the sun sinks in the sky, the longer the shadows become and the more dramatic the effect. If drama is what you are after, use side-lighting to the full, shooting when the sun is at ninety degrees to the camera and low in the sky. For a more natural look, side-lighting is better used when the angle between the sun and camera is less than ninety degrees, with the sun about midway between the horizon and its zenith. At that point, shadows and texture look 'normal', the way the eye is most accustomed to seeing things.

Back-lighting
When the sun moves past the ninety-degree position, you begin to get into back-lighting, sometimes known as contre-jour. When the sun is at an angle between ninety degrees and a point where it is shining directly back at the camera, texture on the lit side of the subject stands out in graphic contrast to deep shadow areas on the opposite side. Shadows slant obliquely across the land, growing longer as the sun sinks lower in the sky.

The scene becomes even more dramatic when the sun is directly opposite the camera. Falling behind interesting cloud formations, the sun produces wonderfully photogenic skies that can be used as subjects in themselves to dominate only a small area of actual landscape within the picture area. When such a sun is fairly high in the sky it illuminates the tops of solid subjects like buildings, but as it sinks lower, less light falls on the top of the subject and the sun begins to draw a halo of light around the edges. This rim light contrasts with the softer light reaching the subject from the front, and isolates it against its background. When back lighting falls across water, it adds a bright sparkle to each individual ripple or wave.

The look and the mood of a back-lit subject change

with the way exposures are handled. With exposure adjusted for the reflected light on the camera side of the subject, the result will be a soft picture with a fuzzy rim of light around it, blending with the background and fusing with the edges of the object itself. If exposure is reduced, the rim of light will appear sharp and bright around various silhouetted objects whose shapes are defined only by these highlights.

When an object is translucent rather than solid, the effect of back-lighting is different. Instead of shining *around* the subject, it shines *through* it. Subjects such as flowers or boat sails immediately take on a glow, almost as though they are being lit from within, an effect that works at its best when the subject is contrasted against a dark background.

One problem that back lighting can induce is flare, particularly apparent when the sun is actually in the frame, but often present even when it is out of the picture area. Flare is caused by direct light on the lens, reflecting back and forth off the surfaces of the elements. The result is a weakening of the overall contrast and, sometimes, the repetition of aperture-shaped marks in a straight line across the picture, a nuisance that can often be eliminated by a slightly different camera angle. More general flare can be reduced by the use of a deep lens hood to shade the lens from the direct rays of the sun.

Overhead lighting
When the sun is overhead or, as described before, as near to overhead as to make little difference, conditions are at their worst for landscape photography. Short, sharp shadows are cast directly down, giving little or no texture or modelling to the subject and creating a high degree of contrast. The overall effect is to give your picture a feeling of heat, but the lighting can be used to advantage perhaps to throw shadows from tree branches on to the ground and so break up an otherwise uninteresting expanse. In general, however, overhead lighting is not recommended

66

for landscape work. If you are forced by circumstances to shoot under these conditions, try to do so when the sun is diffused by cloud, thus diluting the strength of the shadows.

The colour of light

The direction of light in a landscape is not the only factor dictated by the sun's position in the sky. The colour of the light also changes during the course of the day. The molecules of the atmosphere are the cause of this. They scatter the light as it passes through them; the short wavelengths (blue end of the spectrum) are scattered more than the long ones (red end of the spectrum). When the sun is low in the sky, its light must pass through many more miles of atmosphere than when it is overhead, and the more it passes through, the more blue light is filtered out. Therefore the lower the sun is in the sky, the redder is its light.

Around sunrise and sunset, that redness is apparent to the eye, but it is also present to a smaller extent some hours after sunrise and before sunset. Very often the eye (which, together with the brain, adjusts for these changes) won't notice the difference in the overall colour of the light. Film isn't as clever, so colour pictures will show a warm cast at the start of the day and towards its end that you might not notice with the naked eye. The cast can be filtered out (see previous chapter) or even corrected using artificial-light colour film whose emulsion is adjusted for the warm light of tungsten bulbs. Generally, however, the landscape

photographer will want to take advantage of this warm, soft lighting, either to enhance the sunrise or sunset itself or as the source of a more interesting general light for straightforward landscapes. By its nature, this light always falls on the subject from a low angle and is most effective when used as side or back lighting.

The chapter you have just read is one of the most important in this book. It has been talking mostly in general terms, describing how different types of light affect different subjects. In later chapters, we shall be dealing with how those generalities can be expanded and applied to more individual types of landscape.

The sun's rays are forced to penetrate a larger area of the earth's atmosphere at sunrise and sunset than at noon. More atmosphere means greater filtration of blue, so the sun appears redder.

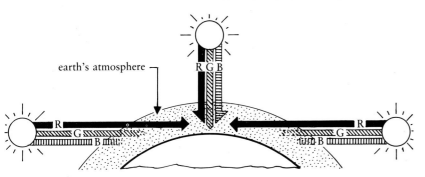

earth's atmosphere

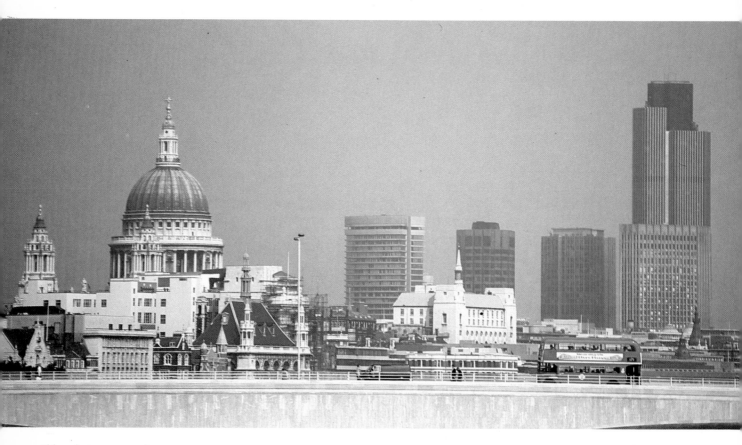

Although tiny compared to the overall picture, the red bus is definitely the most important element here. It is positioned on the third with room to 'move into' and its colour contrasts with, while advancing over, the predominantly blue surroundings.

A picture should be composed so that the eye is led naturally around the frame. The triangular path that this example forces the eye to take is one of the most powerful.

Picture composition

Careful composition is important to successful landscape photography. Very often a change in camera position of no more than a few feet can make or break a picture. When the composition is wrong it jars, even though you can't always say why; when it's right you hardly notice it. All you know is that here is a pleasing picture, and it isn't until you begin to analyse *why* you find it so pleasing that you come to notice the actual composition: the way various elements are arranged within the frame, how certain objects dominate but also balance with others, the arrangement of light and shade that directs your eye in a specific direction . . . all the subtle points that impress or please you when you look at a picture.

A lot of rubbish is spoken about picture composition. Many feel that since it principally involves the artistic side of photography, rather than the more scientific side, there can be no hard and fast rules. It is true that good composition is a matter of aesthetics, and no one is going to deny that having an artistic eye and a good sense of balance is a major advantage. But despite what might be claimed, there *are* certain rules of composition that can be learnt in the same way as you learned to operate the aperture and shutter controls of your camera. Once learnt, and applied with a certain amount of commonsense, they will result in pleasing pictures.

What should be emphasised, however, before we look at even the first of these rules, is that they are not the be-all and end-all of everything. Applying them generally will result in well-composed pictures; applying them with a little extra thought and an artistic eye will make those pictures even better. But just as important is the fact that every one of the rules can be broken. That isn't to

condone a complete disregard for them, but rather to encourage a certain amount of experimentation around them. When you break a rule of composition, it should be in the full knowledge of why that rule works in the first place, and with a justifiable reason for going against it.

The viewfinder

How often does the picture you took bear little resemblance to the subject as you thought you saw it? Very often, objects that you remembered looming large in the viewfinder turn out to be mere specks in the distance of an empty landscape. The reason is that you haven't trained yourself to look through the viewfinder correctly.

Try this small test. Look at some object that is dominant in the scene before you. Your brain tells you that this is the object you want to look at, and in your mind it seems to be the *only* thing you are looking at. Now, without moving your eyes from that object, make the effort to observe what else your eyes can really see. In all probability you will be surprised to learn that you can actually see a much wider field of view than you first thought; your vision is taking in a lot more around your principal subject.

It's much the same when you look through a viewfinder, be it the through-the-lens viewfinder of a single-lens reflex or the direct-vision viewfinder of a non-reflex camera. Your eye looks at some object in the centre of the frame and your brain hooks on to it, leading you to believe that the object is dominating the picture area. When you *really* look, you might well see that it actually takes up no more than one-third of the total viewfinder area and that the other two-thirds are full of distracting subject matter that you have no intention of including in the picture. The answer is to make sure you look through the viewfinder correctly, making the effort to see everything that it contains. Very few people can take in the entire contents of a viewfinder with a single glance. You'll need to hold it to your eye and then, keeping the

camera still, move your eye around all four corners of the frame.

At first it is difficult to look at a landscape and visualise how it will appear within the confines of a picture. For that reason, it is best to keep looking at scenes through your viewfinder and using the method of looking at all corners to get an idea of the way the finished picture will look. Alternatively, you can make a cardboard frame to carry in your bag and hold at arm's length to view your subject. You can even make a frame with your thumbs and forefingers, the way film directors are reputed to do, and view the scene through these. When doing so, it helps to close one eye. Only when you have learnt how to look at a scene correctly are you ready to start applying the rules of composition.

Leading the eye

The whole point of composition is to find a way of making your pictures not only pleasing to look at,

Everything in this picture has been designed to lead your eye straight to the horses. The area they occupy is light in tone; the edges of the picture, by comparison, are dark, preventing the eye from wandering out of the frame; the horses are on a third; and the lines of the path, together with the tree branches, all point the way to the principal subject. *Manny Cefai.*

Use your hands to frame the picture you have in mind, and so get an idea of the way it will look on film.

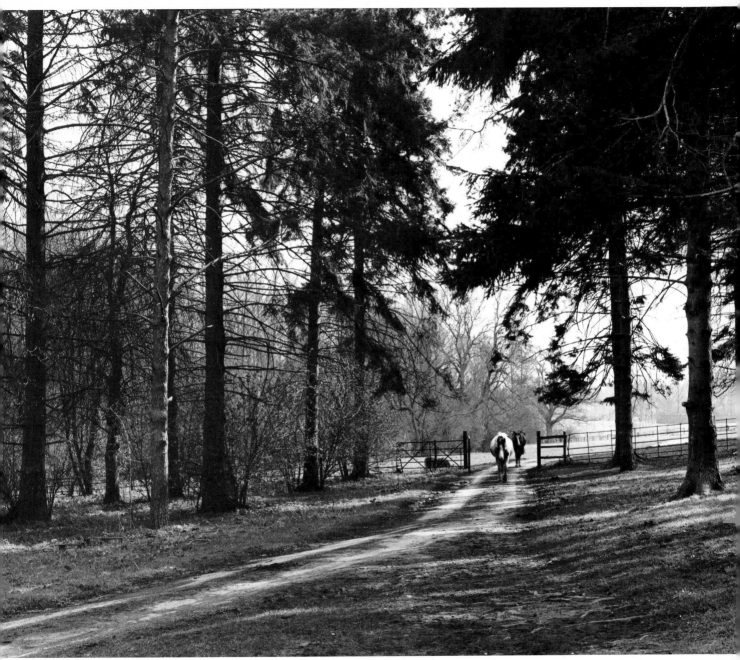

but also easy. The eye is easily distracted; it's your job to prevent that distraction. You must arrange the elements within your pictures so that the eye knows instinctively where to look first and then where to look next. You must find ways to lead the eye naturally around the picture so that it takes in all the elements, without leaving it in any doubt about which is the most important. And you must keep your viewer's eye within the boundaries of the picture itself. It must not be led out.

The way we do this is principally by the arrangement of objects within the picture, their interaction with one another and the lines implied by their juxtaposition. When they are placed in the correct way, the eye is led naturally from one to another; when they are placed in the wrong way, the eye can easily be led straight out of the edge of the picture area. In this respect, light and shade also play their part. Light areas attract the eye; so, unless a specific effect is being sought, the outside edges of a picture should be kept darker than the centre, thus keeping the eye from being drawn towards the edges and out of the picture.

The rule of thirds

This is one of the oldest rules in picture composition, but it is still one of the most relevant. It works like this. Imagine the picture area divided equally by four lines, two horizontal and two vertical. This gives a pattern that can be interpreted in several different ways: you have nine equal areas, three horizontal strips of equal area, three vertical strips of equal area and four points at which the lines cross. Arrange your camera angle so that some important part of your picture falls along any of the four horizontal or vertical lines, and you have the basis of what has come to be accepted as a well-composed picture; place an object on any of the intersections of lines, and you create a powerful design that almost defies the eye to look away.

In practical terms, this means that the horizon in a landscape should not normally fall along the dead

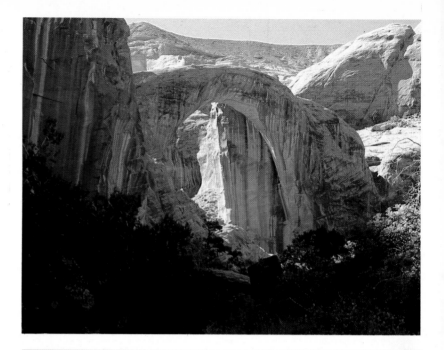

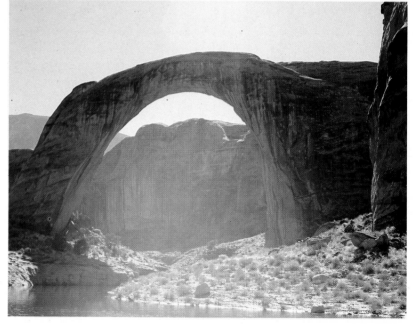

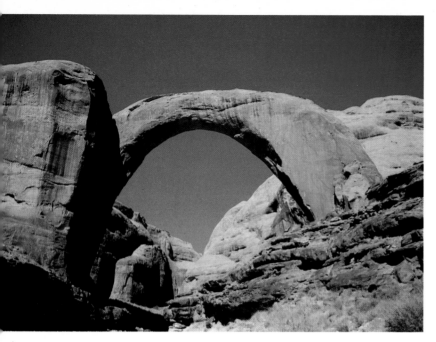

the main composition relying on the relationship between foreground and background objects.

Similarly with vertical subjects such as trees. Place a tree in the dead centre of the picture and you confuse the eye over which half it should concentrate on. It is better, therefore, to place your tree on the left or right third-line, again giving a one-third to two-thirds ratio of space on either side. If the tree or some other object such as a church or cottage is to be smaller in the picture area, it is best placed on one of the four points at which the third-lines intersect.

Space to move

Picture composition does not rely entirely on placing objects on any one of these lines. Very often the choice of *which* line you use can make or break the picture. A tree that looks perfect on one side of the frame might look distracting on the other. This is because an object must have room within the picture to 'move into'. Of course a tree is static; it doesn't actually move. But very often its shape can *imply* movement, perhaps by the way it leans to one side, perhaps by the shape of its branches that appear to be reaching out in a particular direction. Other static objects can have a similar implied sense of movement: a cottage whose roof overhangs in a particular direction, a church whose main building 'points' away from the tower, a fence whose posts lean to one side. And of course there are other subjects involved in landscapes that do physically move: tractors, people on horseback, even flocks of birds.

Before deciding on which side of the picture these objects should be placed, decide first which way they appear to be moving. If the movement is left to right, place the object on the left; if the movement is right to left, place it on the right. Straight away you can see that if the object is to move, either actually or by implication, it now has the larger, two-thirds of the picture area to 'move into'. Placed on the opposite side, it gives the impression of having moved out of the larger area and being

Choice of viewpoint can make all the difference to your picture. Left, above: an interesting rock formation is camouflaged against surrounding rocks, doing nothing to illustrate its true grandeur. Shifting to a different position (left, below) begins to show the height of the arch, but a high sun shining from just the other side of the rocks robs the picture of contrast.

Finally (above), moving to the opposite side of the arch, switching to a wide-angle lens and shooting from a low, close viewpoint emphasises the scene's true character and contrasts the red of the now well-lit rock against the blue of the sky.

centre of the picture. If it does so, the picture is divided into two equal halves and the eye becomes confused, wondering on which area it should concentrate its attention. Shift the horizon up or down and the eye relaxes. It immediately knows which area is the more important and goes straight to it. So the horizon can be placed along the lower line to give a one-third to two-thirds ratio between land and sky, in which case the sky becomes the more important area of the picture, giving it an open feeling; or the horizon can be placed along the top line, giving a two-thirds to one-third ratio between land and sky, and closing the picture in.

In the former case, the sky should be the most important and interesting part of the picture and the land itself need be no more than a thin strip to give an anchor at the base, although the strip should be no *less* than a third of the picture area otherwise the sky can tend to dominate and even begin to look oppressive. In the latter example, the land itself should be more interesting than the sky,

about to move out of the picture altogether, taking the viewer's eye with it. Similarly, if you are concentrating on a smaller object that has been placed on one of the intersections, there should be something within the picture that leads your eye to the subject: a path to the entrance of a church, for instance. In that latter case, the church should be placed on the intersection that allows for the maximum amount of path to appear in the picture, leading the eye to the subject. Again, it's all a matter of implied movement.

There is one more point worth considering before we leave this section. That's the way we actually look at pictures. Western eyes are accustomed to reading from left to right and, although you might not be conscious of it, you very probably look at a picture in the same way, quickly scanning it from the left edge to the right. If in doubt, then, and whenever possible, your principal object will almost always look better on the right of the picture than on the left. This is because the eye first sees the space on the left and then sees the object that is 'moving into' it. The other way round is rarely as effective.

Balance

Having decided where you will position your principal subject, you must then create a balance between it and other elements within the picture area. The viewer's eye should go first to the main subject, find itself led around the picture by other less important subsidiary objects, and finally be led back again to the main subject. Take the example of a picture that has a tree on the right-hand third, whose branches are reaching out across the top of the picture towards the left. Now imagine a cottage in the distance that falls on the lower left intersection of lines. Immediately you have a strong sense of composition. The eye scans the picture from the left and is stopped by the tree's trunk; it then travels back across the picture, following the branches, and alights upon the cottage, from where it travels back to the tree again. The eye is kept in the frame and finds a pleasing juxtaposition of

A change of lens and camera position can make all the difference to a subject as it appears on film. In the first picture (top), the two trees have been photographed straight on with a standard lens. In the second picture, a wide-angle lens has been fitted and the picture taken from a viewpoint much closer to one tree.

74

The tree is the smallest element in the picture, but it is the most important. Its position on the top right-hand third makes it almost impossible to tear your eyes from it. *Frank Peeters.*

objects to continually scan. This triangular route taken by the eye around the picture is one of the most powerful in picture composition. The route can also take the form of a square, circle or oval, but the composition will look more pleasing when an odd, rather than even, number of points are used to draw the eye. Three is the minimum and it is one of the strongest.

Naturally, these subsidiary objects should not

detract too much from the principal subject; they should act more as foils. That isn't to say that they should necessarily be smaller than the main point of interest. In many cases, the main interest of a picture might be some area that is actually very small in the frame, gaining its dominance through position, tone or colour, in which case secondary subjects might actually be larger. The tree and cottage quoted above would make a prime example of this line of thought, if the cottage happened to be

very bright and surrounded by a much darker area. Although the tree would be larger, both physically and in the picture, it would be there to act as a foil, helping to direct the eye towards the cottage.

The tones of a picture can also play an important part in the balance of the image especially in black-and-white photography. In general, light-toned areas appear to be larger than dark. Given two objects in the picture of equal size but of different tone, therefore, the lighter one will dominate the darker one, a factor that might upset an otherwise well-balanced picture. Similarly, given two objects of different sizes, the smaller one lighter than the other one, they might easily assume equal importance although you actually meant one to dominate the other. So when you are planning your principal subject and looking for subsidiary objects with which to contrast it, consider the way their tone as well as their size will register on film. A similar thing happens in colour photography, with certain colours overriding others. That's something we will come to later in this chapter.

Another point worth remembering when you are balancing objects against each other is the way their relative sizes change according to viewpoint. Two trees viewed from a distance might look a similar size, but move in close and the nearer tree will look much larger than the further one, an effect that can be exaggerated still further by the use of wide-angle lenses.

The right lines
Lines in a picture can play an important part in the composition, carrying and directing your eye in appropriate directions. Take as an example a picture showing a tiny cottage with a path leading to it, seemingly lost in the midst of a wide expanse of landscape. With the cottage placed on one side of the intersections of third-lines and the camera angle arranged so that the path starts in the foreground and leads to the cottage, your eye cannot help but be drawn straight to it. Even if its position on the third didn't attract your eye, that

76

Left: the implied 'movement' of the tree in this shot is from right to left. Placing it on the right of the frame with space on the left to 'move into' gives the picture its basis of composition.

The eye is led into a picture by natural lines, but then needs a place to stop. Here, the eye is led by the light tone of the road and stops on a third at the base of the tree. *Ronald Pocock*.

path would, because lines draw the eye into the picture. In the same way, a road that leads from the base of the picture to a vanishing point on the upper third will draw your eye right up the vertical height of the frame. When it gets to the end, it needs a place to stop and that's where your principal subject should lie. It might be something as small as a car with blazing headlamps, but it must be enough to stop the eye and make that tiny object the main interest of the picture.

So lines draw the eye. Used in the way described above, they can be a strong advantage, adding powerfully to the picture composition. But beware. If they don't have anything to stop the eye at their end, the eye will go on travelling, right out of the picture. Lines do not have to be straight. Neither do they have to be as literal as the road or path mentioned above. Lines can also be implied by the placing of objects within the picture: a series of rocks on a beach, for instance. They need not follow a straight line; instead they might form a zig-zag pattern of shapes that the camera angle shows as diminishing in size, all leading the eye in a certain direction through the picture. At the end of the line, there will need to be a stopping point for the eye. In this particular example, maybe a boat on the horizon would do the trick.

Lines, either literal or implied by the placing of objects, can also add to the mood of a picture. Landscapes are mostly made of straight horizontal lines, and these give the picture a feeling of tranquillity and wide open space. Vertical lines give a sense of height, but they can also give a picture a feeling of unrest. Too many, used too close to the camera (a group of trees spaced across the foreground, for instance), act like bars, discouraging the viewer from looking further into the picture. Diagonal lines are dynamic, giving the impression of speed, and unless used carefully they can take away the peaceful feeling your landscape has set out to generate. Curved lines are graceful, leading the eye into and around the picture with more ease than straight lines. The rounded forms of

hills, the sweep of a river or stream through the picture, can contribute in their own way to the composition. Curves, like diagonals, can imply movement, but the movement is slow and restful rather than dynamic. They are particularly suited to landscape photography.

Depth and scale
One of the first mistakes a beginner to landscape photography makes is to photograph a bland scene of rolling hills, or perhaps the view from a cliff-top with nothing in the foreground. The original scene might have been very attractive, but the resulting picture is flat and lifeless. This is because, once you get past a certain distance from the camera, perspective is narrowed and the whole scene starts to take on a two-dimensional appearance. To put back the dimension of depth, you need a sense of scale.

In real life, we accept certain peculiarities of distance. We know that a house in the distance isn't really a couple of centimetres high, even though that's the way it looks. Because we know this, our brain translates it as full-size even though our eyes see it as minute. In photography, we need this optical illusion illustrated and proved to give the picture its sense of depth. If we take a picture of a house in the far distance, it will register small in the picture area, but this isn't sufficient to give us the information we need. It could be a full-size house far away, but equally it could be a doll's house closer to the camera.

That's where foreground interest comes in. If that same house is photographed in relation to, say, a tree only a little way from the camera, scale and depth begin to play their part. The eye compares the size of the near tree with the far house, and straight away an approximation of its true distance is ascertained. The picture at last has a sense of depth. Other useful foreground subjects, depending on the type of landscape you are shooting, include rocks, gates, animals, people etc.

Curved lines give a picture tranquillity, perfect for a subject like this. Again the eye is led naturally around a triangular route, and the boat, to which your eye is continually drawn, is on a third.

Framing the picture

Here we have a further example of foreground interest when the object concerned not only falls into the foreground, but also surrounds it too. The effect can be achieved by shooting from just inside a porch, doorway, arch or window, and it serves two functions that help composition. First, it gives a dark surround to the picture that defies the eye to wander off the edge; second, it helps with the sense of depth as light areas will always appear further from the camera than dark areas.

Natural frames can also be found by shooting from beneath the overhanging branches of trees, through gaps in foliage, through holes in walls and fences . . . in fact from any position that surrounds your picture with a darker area. Composition is helped if the type of frame used matches the subject beyond: the doorway of a building for a street scene or the branches of a tree for a country landscape, to give but two examples. The frames can be sharply defined or fuzzy round the edges, depending on their size and hence nearness to the camera and

depending on how depth of field is controlled. Each has its own effect.

Format and cropping

Composition can also be aided by the final shape of the picture. This might be the way you mask a slide or enlarge a print in the darkroom, or it might rely more on the choice of film format at the time of shooting. In general, horizontal formats work better for landscape photography than vertical, probably because we are so much more used to seeing the world this way. The importance of the horizon can be emphasised much easier than in a vertical format, and there is more scope within the shape to portray any feeling of movement that might be involved within the subject.

The vertical format isn't as common with landscape photography, but used with the right subject it can be tremendously effective. When you look at a vertical picture your eye tends to scan it from bottom to top, so it is particularly useful for emphasising the height of subjects such as trees or tall buildings. Also it gives scope for placing the horizon high in the picture, with maximum subject interest in the lower two-thirds of the picture.

Between the vertical and the horizontal comes the square format. The danger with this picture shape is that it can so easily look dull because neither side dominates; both are equal in dimensions and strength. Because of this, your picture must exhibit a particularly strong sense of composition, either in the conventional sense or in a completely non-conventional way. The square format works well with a picture that actually breaks the rules of thirds, but, as with all rules, if you are going to break them you must have a good reason for doing so.

Whichever format you use, there is no reason to stop at the shape dictated by the film or printing paper. Don't be afraid to crop the picture past what is usually accepted as the natural shape for a photograph. Nobody has decreed that all pictures

must follow the 1:1½ ratio produced by a 35 mm frame, yet it is amazing how few prints and slides are ever allowed to deviate from this shape. Landscape pictures, by their very nature, often look more impressive when cropped right down to a panoramic format approaching 1:3. Given the right subject, such as tall trees, a similar format can be used in the vertical, although this tends to give the picture a rather precarious look as opposed to the firm stability induced by its horizontal equivalent.

Composition and colour

In the section earlier on balance, we discussed the way different tones in black and white can appear to dominate others. This is even more true in colour. According to their colour, different subjects might contrast or harmonise with each other. To understand how that works, it helps to look at a ·

simple colour wheel like the one illustrated here. The three primary colours of light – red, green and blue – have been arranged in segments around a circle, each facing its complementary colour, made up from a mixture of the other two primaries. (Do not confuse these with the way paints mix. Here we are talking about light, not pigments, where the primaries are red, yellow and blue. When you mix the three pigment primaries together, the result is black; mix light primaries and the result is white.) The complementary of red, then, is cyan, that of blue is yellow, and that of green is magenta.

Colours directly opposite each other on the colour wheel contrast strongly with one another, and only slightly less so with those adjacent to the complementary. Colours which are directly adjacent on the wheel will harmonise. You can use this principle to separate objects that might otherwise appear close together, and conversely you can use it to close the gap between foreground and background should that be advantageous to the picture. As an example, consider a green field full of flowers. If the flowers are red, they will *contrast* with green (adjacent to cyan on the colour wheel) and so stand out almost with a three-dimensional look; if the flowers are yellow, they will *harmonise* with green and the picture will appear flatter. The saturation of colours plays an important part as well. A small area of a bright, saturated colour will be as dominant as a large area of a pale version of the same colour.

As well as the effect of contrast and harmony we must remember that certain colours seem to advance in a picture, while others have the appearance of receding. To understand which is which, think of the colours of the spectrum in their traditional order: red, orange, yellow, green, blue, indigo, violet. Colours at the red end of the scale have long wavelengths and so seem to come forward into the foreground of the picture, while those at the violet end have short wavelengths and seem to recede into the background. By far the strongest colour in this respect is red. Even the

red

purple-red

red-yellow

purple

yellow

blue-purple

yellow-green

blue

green

blue-green

smallest amount will draw the eye, so it must be used with great care. Red should not form the basis of a background or be used in subsidiary subjects for fear of dominating and drawing the eye away from the principal point of interest. On the other hand, it can be used to good effect in the foreground of a picture in order to stand out boldly in front of the background and so give the picture a sense of depth.

With these ideas fixed in your mind, you can now begin to use colour as a strong basis for picture composition. One example is when you are working in low light. Whereas black-and-white film might represent the scene as a low-contrast overall tone of grey, colour can be used to lift and separate certain aspects, thus encouraging parts of the picture to stand out more boldly against others. Another interesting way of using colour in composition is to shoot a picture that features an even, monochromatic background and then to position a single item of a contrasting colour in a well-balanced position within the frame. This reference to monochromatic tones has nothing to do with black-and-white photography, incidentally. Although 'monochrome' has come to be accepted as an alternative term for black and white, it actually refers to the use of various shades of any single colour. (In black and white, the colour is black.)

Colour in composition can be used to dictate the mood of a picture. One that is full of contrasting colours appears exciting and alive; another that uses a smaller range of harmonising colours will appear more tranquil. This latter use is of particular interest to the landscape photographer, who can use the absence of too many contrasting colours to allow the eye to differentiate better between the various hues of the harmonising colours; greens and browns of the land blending with the blue of the sky, for instance.

The mistake a beginner often makes is to fill the picture with a confusing mass of colour, to the

extent that the eye cannot decide which is the principal subject and consequently wanders all over the picture, looking for a spot to settle. Once you have learnt a little about what colour does and what it can do for your pictures, you will begin to use it more subtly, to bind certain aspects together and to isolate others. Colour used with a little thought and imagination can make the most mundane subjects appear special; use it the wrong way and you could easily destroy what might otherwise have been a perfectly composed picture.

Cropping a picture to an
unusual shape is another
method of controlling the
composition. Landscape
pictures, by their very
nature, work best cropped
to a horizontal format.
Frank Peeters.

Pictures from aircraft are best shot when the plane is flying low. High shutter speeds are advisable.

Look for details on the beach and then find a different way of picturing them. This seaweed-covered rock was photographed with a 16 mm lens on 35 mm format.

Types of landscape

Purists will claim that landscape photography must be confined to open countryside: hills and fields, a river perhaps, a tractor chugging its way through the late-afternoon sunshine, trees, lakes; and if there is any sort of vehicle or building included, it must be 'traditional', ancient rather than modern. That type of picture is undoubtedly very popular, constituting a high percentage of the landscape pictures taken. Much of what you need to know to take this type of picture has now been amply covered, from the basic technique of using the camera, through choosing your subject and the use of light to the actual composition of your photograph. There is little more that can be said about the general approach to the subject, so in this chapter we will concentrate more on different areas that landscape photography in its widest sense encompasses.

Mountains

Many a landscape includes mountains in the background, but they can also make impressive subjects in their own right, whether shot from the base or from a position on the mountain itself. If you are going to try for the latter viewpoint, bear in mind that mountains are dangerous. Make no attempt to climb steep inclines or rockfaces unless you know what you are doing, or unless you are accompanied by someone with experience. Mountains can be cold places even at the height of summer, the temperature dropping considerably within a few thousand feet. So if you are aiming to go high, dress correctly in preparation. Remember too that the cold could have a detrimental effect on your camera; batteries have a nasty habit of suddenly failing in low temperatures. The best way to avoid this is to use a camera with mechanical shutter control. Failing that, try to keep your camera warm, carrying it *under* your coat rather than on top. Some models feature an auxiliary

battery pack that can be kept in the warmth of a pocket and connected to the camera body via a short lead. If yours has that facility, use it.

The disadvantages aside, mountains provide tremendous scope for the landscape photographer. If you are photographing from the mountainside you will undoubtedly have before you a view of tremendous visual beauty. But remember the rules of composition, in particular that of including some foreground interest. A wide expanse of landscape, however impressive in real life, will still look flat in the final picture without something to give the shot depth. Looking at a picture of a mountain, it is often difficult to judge its height. Try, therefore, to include some recognisable landmark, be it a person, an animal, a tree or whatever, to give a sense of scale.

If you are shooting from the mountain itself, a wide-angle lens is a useful accessory to help include that foreground interest. Shooting the mountain from a distance, a telephoto can often be of help to narrow perspective and so close the gap between the mountain and subjects in the middle distance: a small village some way in front of the mountain can be made to look closer and threatened by its bulk in this way. A lake in the foreground can add to your picture, reflecting the mountain, either as a complete mirror image in still water or as a more abstract design in a rippled surface.

Certain filters are useful for this subject. Yellow, orange and red bring out clouds above the mountain in black-and-white photography; a graduated neutral-density filter will give similar effects in colour. Haze, particularly prevalent on and around this subject, can be reduced with the help of a UV filter.

One final point which might not have occurred to you. If you are climbing the mountain, the air gets thinner the further you climb. That means you could find yourself breathing faster, a good reason for considering a faster-than-usual shutter speed.

Beaches and seascapes
The beach can be an attractive place for a photographer but it can spell disaster for a camera. Your first consideration, then, should be to protect your equipment, which will be under attack from two of its worst enemies: salt water is highly corrosive, and the tiniest amount of sand can jam a shutter or the iris blades of your lens's aperture control. The best way of carrying your photo gear in these conditions is in a heavy-duty, dust-sealed box. The soft-material bags that are so popular for the sake of their lightness will do little to keep out sand. The best rule is to take as little equipment with you as possible and never to put it down on the beach. When you have finished your shoot, and you are away from the location, remove lenses (and, where possible, film) from cameras and give them a thorough clean with a soft blower brush.

Photographing the sea itself is much like photographing a wide expanse of land: it might look impressive at the time, but the picture could end up dull, flat and lifeless. Just as with more conventional landscapes, it needs a point of interest. That can take the form of rocks in the foreground, boats in the background or patterns on the water itself. The sea owes its colour to nothing more than the sky above it, so changes in the sky are going to mean changes in the surface of the water. Backlighting can produce beautiful effects on the sea, as every wave and ripple takes on a sparkle. When the sun is high in the sky, that sparkle can cover a wide area of sea; lower, it draws a narrow pathway of light across the surface.

On the beach, rock formations and pools formed between them make interesting subjects, but move in close and you will find a whole new world of colourful detail that is worth exploring. Once again, the best light is during the early morning or late afternoon when the lower angle of the sun throws shadows from rocks and emphasises texture in the sand. A beach photographed around noon will reflect the glaring light of the overhead

Whether you are shooting *from* or *at* mountains, the subject provides tremendous scope for the landscape photographer. *Frank Peeters.*

sun, turning the sand into a boring, featureless expanse.

Exposures can be a very real problem in these circumstances. If you are forced to shoot around midday, the sand acts like a gigantic reflector. Expose for that and everything else will be grossly underexposed; expose for the surroundings and the surface of the sand will be wiped out by overexposure. The problem lessens as the sun sinks lower in the sky, striking the sand at a more acute angle. Even so, exposures must be watched carefully. You might find your meter indicating an exposure far briefer than you have come to expect. The reflectivity of the sand and the sea is bouncing a lot more light back at the camera than you would find in a more traditional landscape, where grass and earth absorb the light.

Architecture and townscapes
Away from the fields and hills of open countryside and into the town, you will find a new range of subjects that can form the basis of a completely different type of landscape photography. This is perhaps more aptly named townscape or cityscape. The subject is different, but many of the principles remain the same. There is no point in shooting a random collection of buildings in a street any more than there is a point in shooting a bland landscape of fields and hills. The picture needs a centre of interest and something to add scale and depth.

Often it is the details in a town scene that make interesting pictures, rather than the panoramic approach you might use in more traditional landscape work. Look for patterns made by the juxtaposition of one building against another, or the closer pattern that windows sometimes make against the wall in which they are set. Experiment with angles, tilting the camera to give an impressionistic, rather than a literal, view of a structure. Use differential focus to isolate detail like door knockers or some piece of ornamentation on an older building. Watch for modern street signs that make patterns against the backdrop of the sky

Three ways to shoot a sunset. In the first, a standard lens has been used while the sun is still fairly high in the sky, adding a figure in silhouette to provide some foreground interest. As the sun sinks lower, a telephoto lens has been used for the second picture, making the sun the principal subject this time.

The third picture was taken around half-an-hour after the sun had actually set.

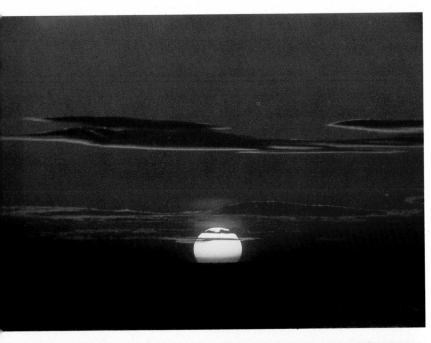

or a suitable building. Look for reflections of one building in the glass front or windows of another, or for the reflection of some totally different subject such as a tree or lake that becomes one with the building in which it is reflected. Blur is also a useful tool in the hands of a townscape photographer, using slow shutter speeds to emphasise the bustle of the streets.

Very often, in these surroundings, a change of viewpoint can give a completely different look to your picture. A building, for example, that stands on the edge of town, bordering overgrown land, will have a completely different look in pictures shot first from one side, then the other. From one side it might look overgrown with weeds, while the opposite view could show it firmly planted in the midst of a busy city.

Light plays a particularly important role in street scenes and architectural photography, affecting different building surfaces in different ways. The reflection of the sun from glass at different angles can give totally different effects; concrete, which is essentially flat, photographs well in strong sunlight with hard shadows thrown across it; brickwork has more texture and therefore needs an oblique light to reveal its surface. Bold patterns in ironwork photograph well when they are back-lit, throwing the structure itself into silhouette and drawing a line of light around the side. Diffused light straight onto an ornate building will reveal its ornamentation better than side-lighting; side-lighting, on the other hand, is useful for showing a dramatic contrast between two adjacent sides of a building.

Different lenses can be used to alter the image of a townscape. Long lenses narrow perspective and so can be used to give a claustrophobic effect of buildings crowding in on top of each other. Wide-angle lenses open up the scene more. Converging verticals are often a problem with this type of subject, and can be tackled in one of two ways: either you correct them or you exploit them.

To correct converging verticals, you need camera movements or a perspective-control lens. The former are found usually on large-format cut-film cameras, and involve shifting the front lens panel upwards so that it remains parallel with the film plane but with the two centres out of alignment. This has the effect of allowing the top of a building, which might otherwise have fallen outside the frame, to be brought in without tilting the camera. Hence the verticals do not converge. The theory is similar with a perspective-control lens, a few examples of which are available for medium-format and 35 mm cameras. Again, a control on the lens allows it to shift parallel with the film plane. For fuller details of camera movements, see the chapter on special techniques.

Without these movements, you will always get converging verticals as you tilt the camera upwards. To reduce the effect as much as possible, try to stand as far away as you can from the base of the building you are photographing and make an effort to shoot it from above ground level, from a window of a building opposite, for instance. If you can get to a position where you are level with a point around half-way up the subject and you shoot with nothing shorter in focal length than a standard lens, you stand a good chance of controlling the convergence. If you are forced by circumstances to shoot close up to the building's base and you cannot get above ground level, there is another useful dodge worth trying. Shoot the building with a wide-angle lens, but point it *down* towards the ground at its base so that the building itself occupies only the top half of the frame, then in the darkroom print only the relevant portion of the negative. If you are using reversal film, you must mask the transparency or make a copy of the top half.

At the other end of the scale, you can ignore converging verticals altogether and use them for their pictorial merit. If that's your aim, use a wide-angle lens where possible. The wider the focal length, the more pronounced the effect.

Aerial landscapes

The landscape seen from the window of a moving aircraft can be very tempting to the photographer, but the resulting picture is often a disappointment. One reason for this is a factor that has been repeated several times during the course of this book: lack of foreground interest. A landscape from the air is a flat expanse with no depth and little sense of scale. The only foreground interest you have available is the wing or an engine of the aeroplane. Including one of those will give the picture better composition, but you might feel it spoils the picture itself. If that's the case, there is no alternative but to shoot pictures that will inevitably lack a sense of the third dimension. Scale can be indicated to some extent by endeavouring to include some recognizable subject matter in the picture: a road with cars travelling along it, for example.

Another problem with pictures taken from the air is their lack of contrast. There are several reasons

If you can't control converging verticals, exploit them. This shot was made by tilting a 35 mm camera fitted with a 28 mm lens.

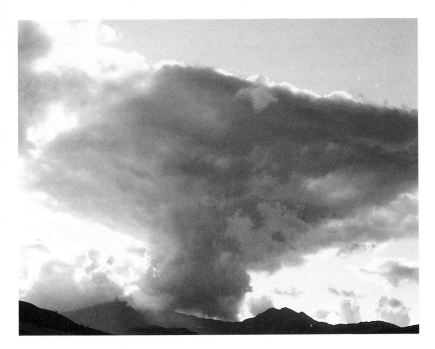

Skies are constantly changing and can offer a range of hues from deep blue to stormy black. They are often best photographed against the light with the sun itself illuminating the subject from behind, giving a bright glow to light clouds or drawing a rim of gold around darker ones. To make the most of the sky in a black-and-white landscape picture, you need to use filters as described in the chapter on basic techniques, but if the sky is going to be a subject in itself you can forget the filters and bring out its true character with less exposure. Do this by exposing purely for the sky and allowing the landscape below to become a dark silhouette. Don't be tempted to photograph *just* the sky; use the dark strip of land at the bottom as an anchor for your picture, but try to make it an interesting anchor by shooting above an area that has some shape in the form of trees or perhaps buildings, rather than just a flat expanse of land. The same holds true for colour pictures. One filter that is useful in both colour and mono is a polariser. Used in the correct way (see the chapter on basic techniques) it can darken a blue sky dramatically and give your sky pictures extra impact.

Skies naturally vary with the time of year and location. Usually they are at their best in coastal regions, rather than inland. Winter is a bad time, since it is either totally overcast or occasionally completely clear. Spring and autumn often provide the best cloud formations; the early part of summer is usually the time for storms, which in turn lead to dramatic skies. Conditions are particularly photogenic at times when the sun breaks out soon after a shower of rain. In these conditions there should still be enough clouds about to make interesting patterns in the sky; the sun illuminates them, either directly or from behind, and the air has been washed clean of dust particles, leaving a clarity that is ideal for photography.

Sunrise and sunset
Taking successful pictures of sunrises and sunsets means being in the right place at the right time with the right equipment. It is common knowledge that

As well as being an integral part of any landscape picture, the sky can make a subject in its own right if the cloud formation is interesting.

for this. You might be shooting through a thin layer of cloud; dust particles in the air naturally scatter light, reducing its contrast; and, assuming you are travelling on a commercial airliner, you will be shooting through several layers of window, the outside of which is probably dirty. This last problem is outside your control, but you can avoid the others to some extent by shooting when the aircraft is flying low. The higher you are, the more the contrast will drop.

When shooting from an aircraft, position your camera as close as possible to the window to cut out reflections from cabin lights, but do not allow it to touch the window itself, otherwise vibrations from the engines will shake the camera and lead to unsharp pictures. For this reason, as high a shutter speed as is practical should be used.

Skies
The sky plays an important part in any landscape but it can also be used as a subject in its own right.

the sun rises in the east and sets in the west, but it is easy to forget that in rising and setting it moves diagonally across the sky. Remember that when you are planning ahead for a certain effect. If the sun is low in the sky above, say, an outcrop of rocks, it won't go straight down behind them. Instead, it will move to the right and probably miss them. To capture the picture you originally anticipated, you will have to move some way to the left in preparation. (For the southern hemisphere, transpose 'left' and 'right'.)

Perhaps the best time to shoot the subject is in spring and autumn when the sun rises later and sets earlier than in summer. Shooting conditions are therefore more convenient, and at these times of year there are more clouds to add to the effect. Clouds are natural reflectors. They pick up the red glow of the sun, adding a constantly changing composition to your pictures. Very often, when the sun is behind a cloud, its rays splay out from all sides, making a particularly striking picture. As the sun goes behind a cloud, a bright rim of light appears around its edge; the same is true of the opposite edge as it leaves. Taking a series of pictures as the sun gradually disappears into one side and then reappears from the other gives another interesting result.

Shooting across water will enhance a sunrise or sunset. A still sea or lake will reflect the sky, giving a mirror image, while ripples across the surface will break up the reflection, leaving a warm glow in the water and drawing a pathway of light from the horizon to the foreground. Shooting from the level of the water will not always show you this reflection. Instead, your picture will be sharply divided into a light sky and dark water. A better result can be obtained by shooting from a higher angle. A nearby cliff-top, if you are working on the coast, is perfect.

Foreground interest plays its usual important role with this subject, but remember that if you are exposing for the sky there will be little or no detail in anything else. Subjects close to the camera, then, should allow for this and be made up of bold lines that work well in silhouette: rocks on a beach, the branches of a tree inland, etc. Because there will be no details in this foreground matter, however, do not be tempted to leave it out. Very often it can be used to frame and 'hold in' the brilliance of the sun, and as such it is very important part of any sunrise or sunset picture.

Exposures can prove difficult. Take a reading directly into the sun and the result will be a picture of *only* the sun, the rest of the scene, clouds included, falling into the darkness of underexposure. Alternatively, exposing for the sky will burn out the sun, leaving it looking like a white mass rather than the golden orb you are setting out to portray. What you need is a compromise. One method is to take a reading from the sun, another from the sky immediately overhead, and use an average of the two. Another method that works particularly well with a centre-weighted TTL meter is to take your reading with the sun just inside one edge of the frame. Its position there is just enough to influence the meter, but not enough to overpower it. Read the setting that gives, and set it manually before repositioning your camera for the correct composition. Whatever method you adopt for measuring exposure, it is wise to bracket with this particular subject, since the difference of one stop either way can change the mood of the picture completely.

Apertures in this context control more than just the exposure. If you use a small stop, you will get a star-like effect on the sun itself; the smaller the stop, the better the effect. Flare can be a problem as the direct rays of the sun hit your lens, so take particular note of what has already been said on this subject in the chapter on using the light. Any lens can be used, but if the sun is to be the principal subject of the picture use as long a focal length as possible. On a standard 35 mm frame, the sun will register as approximately 1 mm in diameter for every 100 mm of focal length. So with a standard

Rainbows occur when sunlight and rain mix. They appear in the sky opposite the sun and can usually be contrasted against dark clouds.

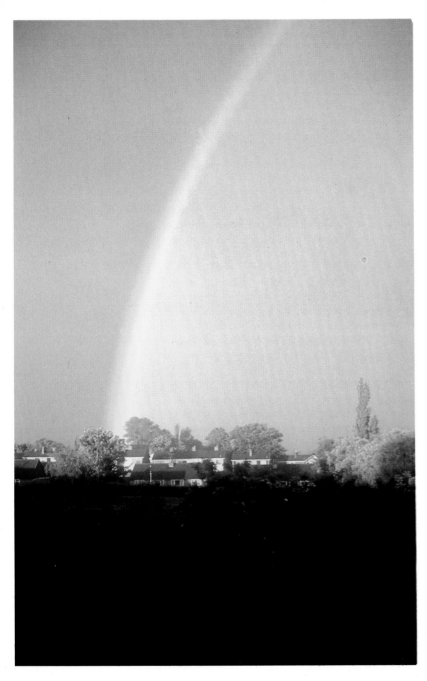

50 mm lens the image of the sun will be no more than 0.5 mm across. With a 200 mm lens that image size becomes 2 mm, and with a 500 mm it swells to 5 mm. Don't forget, though, that when the sun is low in the sky, the light level is also low and you will be forced to use shutter speeds that make hand-holding long lenses impossible. A tripod, then, is a useful accessory with this subject.

When the sun is rising or setting, colour casts change literally by the minute. The lower the sun, the redder its light, and long before the sun appears to be changing colour to the human eye, it will register on film first as deep yellow, then orange, and finally red. The same is true in reverse at sunrise. Remember, then, that the final effect will probably look redder than you remembered it.

Once the sun has actually set, the sky quickly reverts to a dark blue with a band of red light along the horizon. Don't pack up your camera and head for home at this point, because very often the best is yet to come. Watch that band of red and you will see it slowly expanding until, if the night is clear, around half an hour after the sun has vanished, a warm afterglow will fill the entire western sky. This is the time to switch back to a standard lens and to begin shooting. Exposures will be on the long side, but now they can safely be taken from the sky itself, since the glow is uniform and has no actual sun in the frame to influence the reading. The same photogenic glow will appear in the sky at an equivalent time before sunrise. Both are worth capturing on film and can often be more interesting than the sunrise or sunset itself.

Rainbows

Rainbows are unpredictable and last for only a few moments. They occur when the sun shines, usually from a fairly low angle, at the same time as rain is falling. For that reason, they are most frequent at times of the year when weather is at its most changeable, rather on days when it is sunny or rainy all day. As far as it is at all possible to guess when one is going to appear, it is best to position

yourself in open countryside, keeping in mind some subject in the middle distance that can be used as a foil. Remember the rainbow is a natural line and it will lead the eye towards its end. When it gets there, you need a subject such as a tree or cottage to bring the eye to a stop.

A full rainbow is arc-shaped, stretching over a wide panorama of landscape, and would need an extremely wide-angle lens to capture its full diameter. With such a lens, however, the rainbow itself begins to appear as a very narrow ribbon of light. It is better, therefore, to shoot with a standard or medium telephoto lens and try to capture one segment of the arc, which then appears wider and displays its colours far better. Because they form in the area where the rain is falling, rainbows are easily contrasted against dark clouds. But because the sun is shining from the opposite direction, the land beneath might be lit by a warm glow in comparison. Conditions, then, are particularly photogenic. Exposures present few problems. Expose for the landscape in general and let the rainbow take care of itself.

Waterfalls and running water

When water moves within a landscape it can be recorded in two diffferent ways: sharp with every droplet in evidence, or blurred so that its surface resembles soft cotton-wool. Each has its own merits and should be used according to the mood of the picture you are attempting to convey. If the subject is one of peace and tranquillity, you can use the blurred approach by shooting with a slow shutter speed and the appropriate corresponding aperture. A speed of $1/30$ second is slow enough to give the water the desired effect; shooting at an even slower speed enhances the effect to the point where the surface begins to look more like heavy mist than water.

In theory, you can take this idea as far as you like, exposing for minutes rather than fractions of seconds; in practice, the use of extra-slow shutter speeds can create problems of exposure. Even in overcast or shady conditions, and using a slow film, you might find you haven't an aperture small enough to compensate for a shutter speed of less than around $1/15$ second. The problem can be solved by the use of filters whose factors demand extra exposure. In mono photography you can use deep-coloured filters such as red or blue, bearing in mind the effect they will also have on the tones of the picture, or you can use neutral-density filters. In colour, unless you want to give the picture a weird colour cast, you can use only neutral-density types. (See the chapter on basic techniques.)

At the other end of the scale, you can use extra-fast shutter speeds and their corresponding apertures to freeze the motion of the water. A shutter speed of $1/1000$ second will easily do the trick, but remember that depth of field will now suffer from the extra-wide aperture you may well have to use. With a speed as fast as this, every droplet of water will be frozen on the surface and in mid-air, giving the appearance of solidity. The effect can be enhanced by shooting with the subject back-lit to give an extra sparkle to the droplets.

Neither of these two extremes will record running water the way you think you see it with your eye. We certainly don't see the subject in its blurred state, but neither do we actually perceive it in its 'frozen' form. To record running water the way it looks to the eye, use a shutter speed of around $1/250$ second.

A shutter speed of around $1/250$ second will record running water the way it appears to the eye.

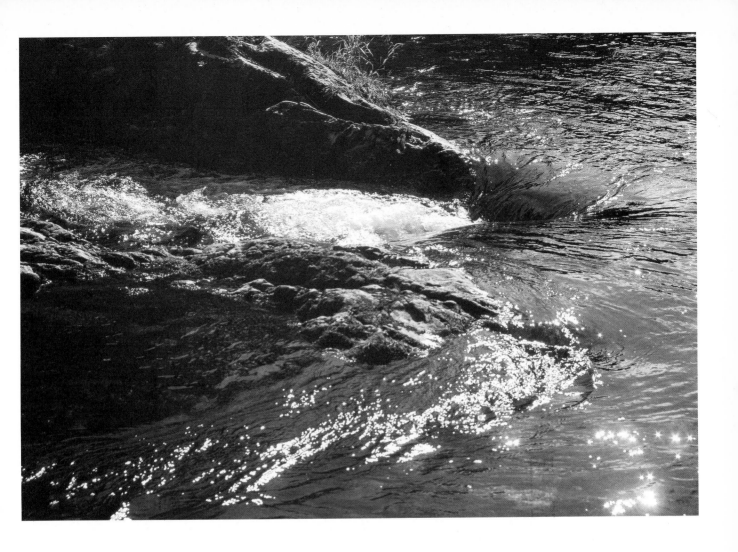

The quality of dull light when given adequate exposure can often be quite surprising. This shot was taken on a late winter afternoon, the light level demanding an exposure of $1/30$ second at $f/4$ on a medium-speed film.

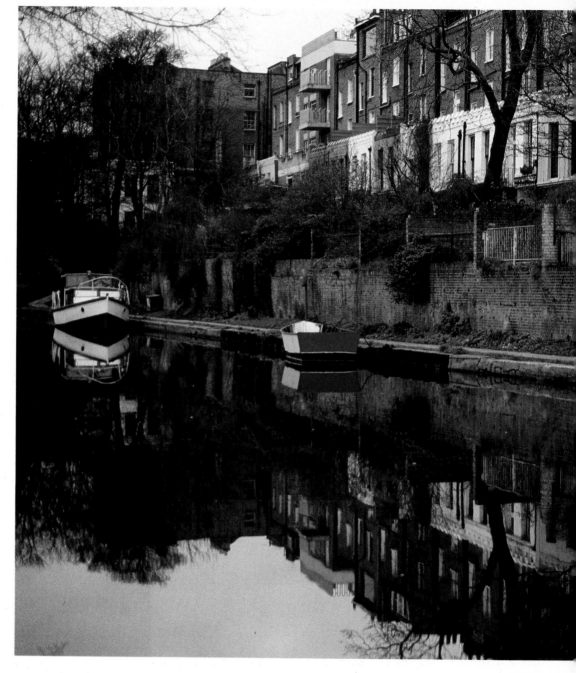

Different conditions

Landscape photography, relying as it does on shooting pictures outdoors, is continually affected by changes in weather and light. But don't think that because the sun has gone in, it's time for you to do the same. The presence of sun in a picture in some form or another is often thought of as a prerequisite for successful outdoor photography, but many conditions thought of as unsuitable can result in different and individual pictures that are far more interesting than straight shots taken in the 'right' weather. In this chapter, we are going to look at shooting when many think you shouldn't.

Dull days
With cloud cover at its maximum, light levels fall and contrast is drastically reduced. Conditions are not at their best, and yet there is a quality about the light that, with the right subject, can be exploited. Colour is often a better medium here than black and white. Cameras need wide lenses and/or fast film. You will find yourself shooting at wider apertures and slower shutter speeds than you would normally use, so remember the effects of aperture on depth of field, and do not use a shutter speed slower than is practical with the lens in use. (See the chapter on basic techniques.)

When the day is dull, shadows are practically non-existent and so detail that might otherwise be lost is often revealed. Colour tends towards the subtle, and although this can be a disadvantage in some subjects it can actually enhance others. A scene that, in sunlight, might be full of bright, discordant colours now becomes far more harmonious. If, however, you want to pick out some specific subject against others, remember the advice given on colour in composition (the chapter on picture composition) and use advancing colours to contrast against receding tones.

In some dull conditions, the light can create a luminescence on certain subjects. Whites seem to glow against darker backgrounds. It isn't always easy to see at the time of taking because of the overall dullness of the conditions, but train your eye to look at the reflectance of certain objects against others and you will begin to see the effect. This is something that is especially true in storm conditions. Very often, the moments before a storm actually breaks can be particularly photogenic. The sky is not just overcast, it borders on a number of subtle colours that at any time can look black, grey or even a dark shade of green. Against this, light-coloured objects stand out starkly. The quality of the light in these conditions, both straight and reflected from objects in the picture, is unique.

Exposures in this type of light will be at a maximum, as much as $\frac{1}{30}$ second at $f/2.8$ being quite common on an average-speed film. The subject will be dull, but the exposure will lighten it, resulting in a picture that exhibits an atmosphere impossible to recreate under any other conditions.

Rain

When it starts to rain, contrast falls to a new low. Again, colour works better than black and white in wet weather, although the latter can be used to shoot a scene that, with its contrast increased by processing, results in a picture that exhibits tremendous atmosphere. With colour, the various shades are washed out and merge into pastel hues. Definition of a picture is reduced by the falling rain – you are, in fact, shooting *through* millions of drops of water. This is something you won't avoid, so exploit it instead to give the picture its own identity. Slow shutter speeds will blur the actual fall of raindrops; a speed of $\frac{1}{125}$ second or faster is needed to actually capture their fall. If the aperture of your lens or the speed of your film allows you to use speeds as fast as $\frac{1}{500}$ second in these conditions, you can more easily capture the patterns made by rain as it falls on wet surfaces and into puddles; slower speeds will not always be fast

enough to capture the patterns as they form and vanish. Try to combine the circular ripples made by raindrops with reflections in puddles. Look too for close-ups of rain that has fallen on subjects like flowers or blades of grass.

Rain can also be shot from indoors or from the inside of some vehicle when the scene outside might be made more surreal by shooting through water on a window. Focus on the droplets and let the scene beyond blur, or focus on the scene itself, allowing the blurred water in the foreground to add pattern and mystery to the picture.

One of the problems of shooting in the rain is protection of your equipment. If your camera gets wet, dry it as soon after use as possible, and try to avoid raindrops actually reaching the lens or any filter you might have in front of it. They will affect definition of the picture. If you think you can shoot one-handed, or if you have a friend to help, take your pictures from beneath a large umbrella. Alternatively, keep your camera in a plastic bag with a hole for the lens to poke through. If the bag is made of thin enough material, it is surprisingly easy to operate the controls from outside, and here is one place where a motor drive or power wind is particularly useful. At the least, keep your camera under your coat and remove it only to take the picture.

Snow, ice and frost

Snow pictures *can* be taken when the sky is overcast, but the result is usually a very low-contrast picture with, in colour, a blue cast. Such pictures need some brightly coloured object strategically placed to give some point of interest and so lift the otherwise dull atmosphere. Snow pictures are better shot when the sun shines just after a fresh fall. Immediately, the dullness of the snow vanishes as the sun gives a sparkle to its surface; shadows from trees, fences, etc. contrast with the whiteness of the ground; and the whole landscape harmonises with the blue of the sky. Back-lighting or strong side-lighting gives the best

Shot originally in the drizzling rain, this picture was enhanced by rephotographing the original print and then exaggerating the grain by a reticulation technique. *John Green.*

99

results. Details within the landscape also lend themselves well to these conditions: snow lying along a pattern of branches, for instance.

Technically, shooting snow can provide a few problems for the unwary. The first of these is exposure. Remember that most meters set out to evaluate everything as a standard tone of grey. That's usually quite adequate for the average subject, but point your meter at something as white as snow and you create a problem. What the meter 'thinks' is correct is an exposure that renders the snow as grey. In other words it indicates severe underexposure, and pictures shot at the indicated setting will be dull, showing dirty-looking snow. The solution is to ignore the snow itself and take your readings from some other area, closer to the camera, where the meter will not be affected by the dazzling white. A grey card is ideal, but failing that use something of an equivalent tone or even the palm of your hand. Alternatively, take the reading indicated by your meter or camera and open up by one or two stops. The next surprise is that even *that* reading might seem too low by normal standards. Although your reading might appear to be around one stop less than the expected exposure, it is in all probability the correct one and has been caused by the presence of the snow itself. With the ground covered in white, it is acting like a gigantic reflector and so affects your overall exposure.

This reflectance can cause other problems. With a blue sky above the landscape, the snow reflects that colour and takes on a blue tinge. As with so many other colour casts, your eye and brain tend to ignore this, simply because your brain knows that snow is white and translates it as such. The film, however, sees and records it as blue. The cast is only slight and can enhance the picture, but if you want to correct it, use a pale straw-coloured filter such as an 81A or 81B. Because you are using around one stop less exposure on the landscape than normal, blue skies will be rendered darker than usual; in these circumstances don't be tempted to use a polarising filter to darken them even more.

The sky will be darkened, but the filter will also destroy the sparkle of the snow.

Ice and frost are also photogenic and, in close-ups at least, are subjects that can be shot as well in overcast conditions as when there is a little sun to give them sparkle. Both cling to the edges of plants and leaves, and follow the delicate membranes that support most foliage. If you need an extra sparkle, use a small, hand flashgun on an extension cable to provide a little extra side- or back-lighting. Watch too for icicles and shoot those in close-up. They are particularly effective photographed against the rays of a low sun if conditions lend themselves to it. All the pictures mentioned in this section work well in both colour and mono.

Mist and fog
When you start to shoot in mist and fog, you are working in conditions of the very lowest contrast and usually, when there is no sun at all, with a blue cast. What the picture needs, then, is some extra-bright point of interest. This can take the form of an object or person placed in the foreground, preferably made up of, or dressed in, something red. Better still, it can be an actual light: a street light or car's headlamps in an urban subject perhaps, or the sun just breaking through the mist in a more traditional landscape. When the sun is high in the sky it will take the form of a pale yellow, almost white, disc; when it is lower in the sky, its inherent colour cast will illuminate the mist itself, giving the whole picture a warm, sepia-like quality.

Mist and fog allow you to reduce pictures to the simple basics. They mask out a background that in normal conditions might have been distracting, and because the camera cannot see very far they allow you to use just one or two subjects sparingly to build composition. Try to find a location near a hill on misty days, because at different heights there will be changes in visibility. At the bottom of the hill you might be in thick fog, at the top the sun could be shining in a clear sky; between the two

There is often a magic time just after a fall of snow when the sun emerges. Such moments work well in colour.

Snow in dull weather is often best rendered in black and white. A similar shot in colour would have taken on a blue cast unless corrected by filtration. *John Russell.*

you will inevitably find conditions that are absolutely right for the type of picture you had in mind. There is, in fact, an almost magical position half way between the two extremes where the sun just begins to overpower the mist and that is probably one of the best places for photography. At the top of the hill, don't forget to turn round and look back down. Here, the sun might be shining from a clear blue sky; beneath you, the tops of trees and houses are likely to be isolated like thousands of tiny islands in a sea of mist.

In the early morning, mist often rises from the surface of water, making a subject that is best photographed with a little back-lighting to emphasise its qualities. Conversely, in the evening, mist can be seen actually rolling down the sides of steep hills or mountains, making another unusual subject for the landscape photographer.

If in doubt about exposure, expose for the highlights. A little overexposure can penetrate the mist slightly, but be especially wary of overdoing the effect; it's all too easy to wipe out the atmosphere completely by too much exposure. A reading taken from the palm of the hand will give a good basis for any doubtful subjects; from that, bracket by half-to-one stop each way.

Dusk

Dusk is usually associated with that time between sunset and the moment when it is finally dark. But the word applies equally to the other end of the day, between night and sunrise. It's a time that many photographers forget about, and yet it can be one of the most beautiful, offering light that is soft and tinged with colours that vary from gold, through deepening shades of red, purple and blue. It should be of special interest to the landscape photographer.

Every moment of dusk gives a change of light, none of which lasts for long, so it is best to position yourself in advance, concentrating on an area that you know will benefit from the very special light.

Be prepared for skies, light towards the horizon where the sun will rise or has set, growing darker overhead. In the direction opposite the sun's position, the sky will be darker still. For some minutes after the sun has set, clouds above and behind you will be tinged with red, pink and orange along one side, fading to darker greys on their opposite edges. As the time passes, so clouds above and behind you lose their colour, but those towards the direction of the sun still hold theirs. Gradually, a band of red will spread from the horizon to fill the western sky. (The opposite is of course true at sunrise.)

The effect of dusk is prolonged the further north you travel in the northern hemisphere, and the further south in the southern hemisphere. At the extreme, dusk lasts all night at certain times of the year; at the equator, it is over almost in minutes. Many dusk pictures owe their effect to the sky, so shooting near water will double the effect as the sky is reflected in its surface. As you get further away from the sunrise or sunset, the light becomes more blue. Reds turn purple and light objects such as white houses stand out luminously against the surrounding countryside. You can use that fact to give your dusk pictures a strong point of interest. If buildings are included in the scene, this is the time of day when lights are turned on; illuminated windows help to intensify the atmosphere of the picture.

Exposures will be long at this time of day, and a tripod becomes an important accessory. When the sun is below the horizon nothing will be lit by direct light, only by that reflected from the sky, so fast film and lenses are very useful. Exposures based on readings taken from the sky at this time will throw the landscape into silhouette; expose for the landscape itself and you will lose the delicate shades of the sky. You will have to decide which is the more important to any particular picture and then expose accordingly. Either way, dusk allows you to shoot in a light not seen at any other time of the day.

Mist and fog allow you to reduce a picture to simple basics. The addition of a low sun helps to lift the picture.

After the sun has set (or before it rises), the soft light of dusk can make it one of the most beautiful times of day for landscape photography.

Night

Photography need not be confined to the hours of daylight. The camera can be used just as effectively at night, a time when the landscape photographer will probably turn his attention towards the town and city. You'll need a camera with slow shutter speeds and a B setting, a cable release, a firm tripod or some other reliable support, and a small torch. This last item can be particularly useful, not only to see the camera controls by, but also as an aid to focusing. You can shine it on a subject when existing light makes conditions too dim to see the focusing screen, or you can place it beside a close subject and focus on its actual beam. If the scene you are photographing has a dark surround, you might find it difficult in the dark to see where it ends in your viewfinder. A torch can be useful here too; shine it into the lens, if you are using an SLR, to identify where the edges of the viewfinder fall.

Fast film is an advantage but not a necessity, since exposures will inevitably be on the long side anyway. Unless you specifically want an extra-fast film for hand-held photography, stick to the medium-speed films and the better quality they produce. When shooting in colour, remember that reversal film is balanced for either daylight or artificial light. For true rendering of the subject, then, you need the tungsten-balanced stock, although the warm cast given by daylight-balanced film in these conditions is often preferred. Try both and see which you prefer.

At best, exposure for night photography is a compromise. Too little and you get highlight detail, usually representing actual lights, surrounded by jet-black shadow areas; too much and you get detail in the shadows but the highlights will be severely burnt out, a problem that is compounded when shooting in colour as the extra exposure induces a colour shift that can give a predominantly brown image. You must find a happy medium, and very often it is a matter purely of personal choice. Experiment by shooting in a brightly lit street. Take a reading off the pavement and another from the actual light source. Shoot a number of exposures between these two, as well as one direct average of the two extremes, and see which you find most pleasing. Once you have taken one roll of film in this way and seen the results, you will begin to know exactly what you need for your particular preference.

Starting your night photography at dusk produces striking pictures. While there is enough light left in the sky, buildings will be silhouetted against its dark blue or maybe red, while lights from the buildings give you the effect of night. Wet pavements and puddles enhance night pictures, reflecting lights and giving you detail in areas that might otherwise have fallen into dark shadows. For that reason, exposure can be shortened when the ground is wet.

Anything that moves during a long exposure will record as a blur. If the moving object has a light on it (the headlamps or tail lights of a car, for instance), the light will be recorded as a line. You can use this to create interesting effects, setting up your camera at the side of a busy main road. With the aperture closed down to around $f/16$, you can make long exposures of as much as twenty or thirty seconds, recording the many vehicles that pass as light trails. Headlights will record white, tail lights as red, and flashing indicators as dashes of yellow.

Fairgrounds make interesting subjects for night photography. You can use relatively short shutter speeds with wide apertures to record the scene in general, or long shutter speeds with small apertures to blur the moving lights of roundabouts etc. to make abstract patterns. Floodlit buildings can be another target for your camera. With these, you must expose for the building itself. If the floodlights are based on the ground, pointing up at the building, remember that their effect will fall off towards the top, and that could result in a picture of a building whose top seems to fade away to nothing halfway up. Try to expose, therefore, for a point towards the top of the building and allow the

base to take care of itself. If you are handling your own processing, you can shade the picture at the printing stage to give the base extra exposure and so produce a more evenly lit subject. Neon signs are among the simplest of night subjects. With these, you can allow your camera's TTL meter to take care of everything, exposing just for the sign against a black background. Multiple exposures (see the next chapter) of different signs on the same frame can give interesting results, as can zooming a lens aimed at the sign during the course of the exposure.

Throughout this book, continual reference has been made to the use of a tripod or similar support at slow shutter speeds, but there are times when a slow speed *must* be used and there is no way of supporting the camera. Then it's worth remembering something else that has been mentioned a few times within these pages: rules are made to be broken. It is not advisable to hand-hold the camera at extra slow speeds, but if the alternative is no picture at all, then go ahead and try. This is particularly pertinent to night photography. Despite everything that has been said before, it is possible to hand-hold very slow shutter speeds. It is easier with a non-reflex camera than with an SLR, since there is no moving mirror present in the former to add its own vibrations. But even with a single-lens reflex it is possible to hand-hold speeds as slow as ¼ second with a standard lens and still get an acceptable result. Not a *perfect* result, but an *acceptable* one. Depending on your age, state of health and general steadiness of hand, you might find you can go even slower. Here's how to do it.

Stand in a relaxed position: legs a little way apart, weight evenly distributed on each foot, camera to the eye and elbows tucked well into the body. Focus, hold your breath and slowly squeeze the shutter release, concentrating on moving that finger and nothing else. Do not take a deep breath and hold it while you adjust focusing and framing. That will only make matters worse. Just breathe

normally and *momentarily* hold your breath as you press the release. If you can find something solid to lean against while you do this, so much the better, but it is not essential. Better still, hold your camera tight against a firm post, the side of a building or a wall and press the shutter release in much the same way. If your camera has a delayed-action device, you can use this to set off the shutter so that you don't even need to move a finger at the moment of exposure. None of these methods is ideal, but it could get you out of a spot and give you a picture in conditions that you might have thought impossible. The above methods have proved successful for the author when using ¼ second with a standard lens on an SLR. The speed would need to be faster with a longer-focal-length lens, but could easily be slowed down even more with a wide-angle lens.

Moonlight
Taking pictures by moonlight obviously needs long exposures, so your first requirement is a subject in which there is no movement. On mono film, the result will look little different from a picture taken by sunlight; even the sky will look light if the exposure is long enough. On colour film, a blue cast will be present, but that adds to the impression of moonlight. Focusing can prove difficult in low-light conditions, which are usually too low for the focusing screen of a single-lens reflex. A torch can be used to read the focusing scale or for focusing upon, as described earlier. Exposures will run into minutes rather than seconds, and will be affected not just by the actual level of light but also by reciprocity failure. A certain amount of trial and error will give the best results, depending on the phase of the moon and the number of clouds present, but a good starting point that will give definite results on which to base further experiments is an exposure equivalent to 25 minutes at $f/5.6$ on ISO 100/21° film, shooting by the light of a full moon.

With exposure of this length, do not try to include the moon itself in the picture. The length of the exposure will wipe out any detail in its surface, and

its movement across the sky during a long exposure will result in its being recorded as an oblong blur. For a more realistic effect, shoot first with the moon out of the frame and with an exposure that keeps the sky dark; then make a second exposure, on the same frame, of the moon in an appropriate area of blank sky (see the next chapter for the technique). Switching to a lens of a longer focal length for this second exposure will cause the moon to look bigger and actually more realistic in the final picture. An average exposure for recording a full moon with no other detail around it is $\frac{1}{60}$ second at $f/5.6$ on ISO 100/21° film.

Two ways of shooting night pictures. In the first, a relatively short exposure has been used to record principally the lights themselves against a black sky. In the second picture, a longer exposure has been used to show more detail in a shot taken while there was still a little light left in the sky. Both were taken on tungsten-balanced film, and a cross-screen filter was used for the second shot.

In mono, infrared film causes foliage to turn white, skies to record extra dark. *P. G. Sewell.*

Opposite: solarisation produces a part-positive, part-negative image on the same piece of film. *Roger Darker.*

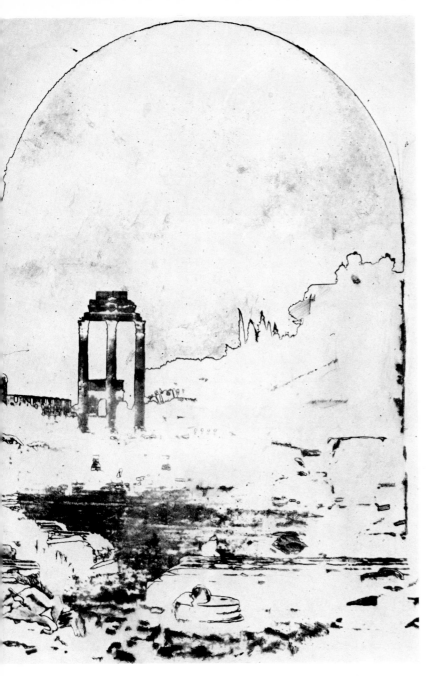

Special techniques

So far we have looked at different types of landscape, but mostly shot in a conventional way. Now we are going to cover some of the more unconventional ways of taking and, in the darkroom, of making landscape pictures. The techniques covered in this chapter might be scorned by traditionalists who claim that landscapes should be shot 'straight', without the need for gimmicks to enhance the scene, but if you have read this far you will have realised that while traditional approaches are respected in this book they are by no means considered the *only* way of dealing with its subject. Even the most dedicated of purists will probably admit to having occasionally used a filter of some kind to enhance clouds. And with that he will have entered, albeit only in a small way, the world of special techniques.

Before you try any kind of special technique or effect on a picture, ask yourself the very important question: does the end justify the means? In other words, are you using the technique for its own sake or in an attempt to cover up some fault in the original picture? Alternatively, will its use genuinely add something to the atmosphere or composition? If you can truthfully answer yes to the last question, you are using special techniques for the right reason. There are many different types of special effect that can be used in landscape photography, both at the taking stage and later in the darkroom. Images can be coloured, multiplied, softened, coarsened and even changed to the extent that the original subject becomes no more than an abstract pattern. Here are some of the ways that you can use special techniques to give a different look to your landscapes.

Filters
Filters have already featured in earlier chapters, dealing with their traditional uses for separating

similar tones of grey in mono photography and for correcting casts in colour. But there is another type of filter designed specifically for adding certain special effects to your pictures. Many of these would better be termed 'optical devices', since they change or add to the image rather than filtering it in any way. But for the sake of convention and ease, we will refer to them all simply as 'filters'. Some of the more popular types are listed below.

Cross-screen filters are undoubtedly among the most popular special-effect devices. They are sometimes known as star-cross, sunburst or simply star filters. Fitted to the lens and pointed towards a bright light source such as the sun or a street light at night, they produce lines of flare, spreading out like spokes from the centre of the light. The effect is caused by fine lines etched into the filter material, and the number of 'spokes' of flare varies with the pattern of the etching. The filter is most often used in landscape photography to add flare lines to the sun. Unfortunately the effect is sometimes overdone, and in many cases the picture would be better without the filter. Use cross-screen filters, then, with care and only if you genuinely feel that their effect will add something worthwhile to the landscape. They work best when the flare patterns fall across dark areas of the picture, hills below a low sun, for instance, as opposed to the open sky when the sun is higher. Stopping the lens down reduces the effect, so they are best used at medium to wide apertures. They should not be used at small apertures with extra wide-angle lenses, since the large depth of field that is inevitable with such a combination can sometimes show up the actual etching on the filter.

Diffraction gratings are similar to cross-screen filters, except that the lines are etched in a way that sets up an interference pattern across them, breaking the flare patterns down into the colours of the spectrum. Thus multi-coloured 'spokes' of light are created from sources such as the sun. The advantages and drawbacks of diffraction gratings are exactly the same as those of cross-screen filters.

1

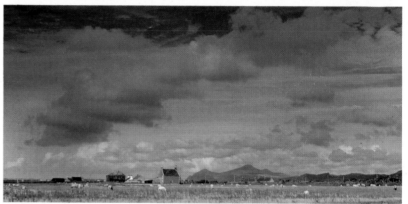

2

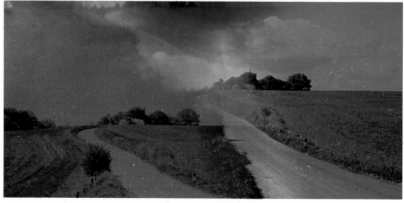

3

Here are just some of the many special effects that can be introduced to a landscape picture with commercially-available filters.

1 and 2 Graduated filters can be used to change the mood of a picture. These two landscapes were taken with and without a graduated tobacco square filter.

3 A multi-vision coupled with a multi-colour filter repeats and colours the image.

4 Three shots on the same frame, each through a red, green, then blue filter, produced this striking effect on back-lit water.

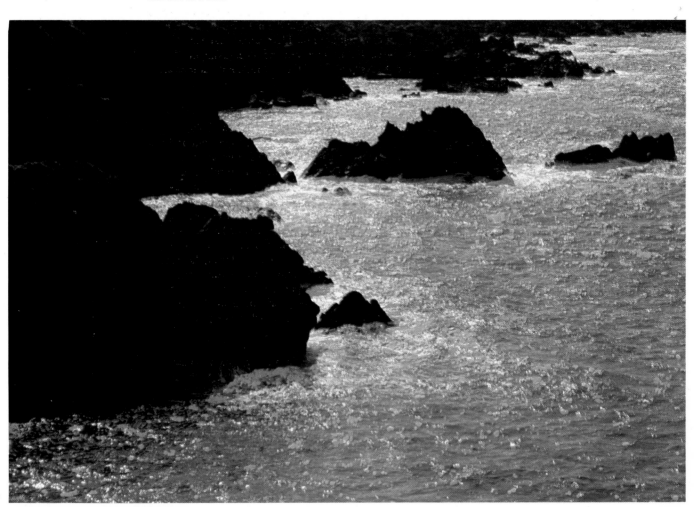

4

Graduated filters come in a range of colours and neutral densities. They are usually of the square type, fitting into a filter holder which, in turn, fits to the camera lens. Their coloration changes in density from a saturated tone at one edge, growing lighter and then completely clear on the opposite rim. They can colour one part of a picture without affecting others, and in landscape photography are most often used to introduce their colour to the sky area, although they are in no way restricted to modifying the top half of the frame. If they are of the square type, they can be slid up and down in their filter holder to affect exactly the right area. The most useful colours for the landscape worker are blue to enhance an otherwise grey sky, or one of several shades of red to give a sunrise/sunset look to a perfectly normal sky. A graduated neutral-density filter can also be used to darken a sky without affecting its actual colour; in black and white it can be used to reduce exposure on that area and so encourage clouds to reproduce better than would otherwise be possible, short of using one of the yellow/orange/red filters more normally associated with this technique.

Duo-tone and tri-tone filters use two and three colours respectively to give two or three distinct colour casts to a scene. Their effect rarely looks natural and they are more often used to produce a slightly surreal image. With the tri-tone variety, the colours can be arranged either in strips across the filter or in segments around it.

Multi-image filters split the picture into several identical images, the number depending on the number of facets that have been cut into the filter material. Depending too on the cutting of the facets, the images might be arranged in parallel or in a circular pattern. They are best used when the subject is brightly-lit against a dark background, allowing the images of the subject to be repeated against dark areas. With too light a background, the subject can easily be wiped out. Colour multi-image filters are available in their own right, or can be made up from a combination of duo or tri-tone types with standard multi-image types. As might be expected, they multiply *and* colour the subject.

Centre-spot filters have a clear spot in their centre, surrounded by a colour or a tone of neutral density. They allow the principal subject to be recorded normally, surrounded by a halo of the relevant colour.

Vario-colour filters are made up from three polarising filters, two of opposing colours mounted with a grey filter between them. By rotation of the mount the colour of the filter can be changed between, for instance, red and blue, taking in all the shades between. Other colour combinations are also available.

Harris shutter
This is a device containing red, green and blue filters which can be spun or dropped in front of the lens at the moment of exposure so that one frame of film is exposed to the same scene through each of the colours, one after the other. (A similar way of achieving the same result is to use three separate filters and to make a series of multiple exposures, on the same frame, through each one.) Since red, green and blue are the main constituents of white light, anything that is standing still during the three exposures records normally, while anything that has moved between exposures records in one of the three colours. The effect works particularly well on waterfalls and back-lit water, when every drop stands out as a different colour.

Exposure is calculated by taking an initial reading without the filters in place, dividing this by three and using the result as your basic exposure, adjusting each according to the filter factor. If that sounds complicated, forget it and try this more general rule of thumb. Take an initial reading without a filter, open up by one stop and use *that* exposure for each of the three shots. If in doubt, bracket exposures by half-to-one stop each way.

Multiple exposures

The combination of two or more images on the same frame of film can be used for two very different end results. In the first, several different subjects might be combined to make a pattern (as of neon signs in night photography, for instance) or to produce a totally surreal picture that might show a landscape combined with perhaps clouds or water, or even with a face or a silhouette. In the second type of multiple exposure, images are combined more subtly so that the trick isn't immediately evident in the final picture. This is most often seen in the combination of the moon shot with a long-focus lens over a landscape shot with a more standard focal length.

There are two different techniques. Images can be combined one over the other so that subjects appear ghost-like and blending with each other, or one light-toned image can be superimposed on the dark area of another. In either case, the light areas of one image will always shine through and blot out the darker areas of another. If two equally lit areas are to be combined, it follows that the final picture will actually receive twice its correct exposure. Each separate exposure therefore must be reduced proportionally. If two exposures are being made on the same frame, each exposure must be halved, by closing down one stop; if three exposures are being made, you must close down one-and-a-half stops; if four exposures are needed, exposure must be reduced by two stops. In the second type of multiple exposure, each image is recorded in a dark, and so unexposed, area of film, so the overall level of exposure in the finished picture is not affected. Exposures can be metered and set in the normal way.

The best type of camera for multiple exposures is one that does not have a double-exposure prevention device. The ideal is a studio model. The next best is a medium-format or 35 mm camera that has a multiple-exposure device allowing you to override the safety lock. Without these refinements, multiple exposures are more difficult, but they are by no means impossible. To override the double-exposure prevention device in a 35 mm camera without multi-exposure facilities, the following procedure can be used.

First, use the rewind knob to take up any slack present in the cassette by turning it gently in the direction of its arrow until it to comes to a stop. Now press the rewind button (usually found on the camera's baseplate) to free the film transport mechanism in the same way as when the film is being wound back into the cassette. Finally, keeping your thumb on the rewind knob to prevent film movement, advance the lever wind through its full throw. This will have the effect of cocking the shutter without advancing the film, and a second exposure can thus be made on a single frame of film. The procedure can be followed for any number of exposures, but when the last exposure has been made it is advisable to advance the film *two* frames rather than the usual one; otherwise, with the rewind knob still depressed, the film might not advance its full width and overlapping of frames could result.

Soft focus

A landscape shot in soft focus is not actually blurred, although at first sight it appears to be less than sharp. In fact it *is* in focus, but the image has been diffused so that highlights spread into shadow areas, giving an overall soft look to the image. There are several different ways of achieving the effect, some more expensive than others, but whatever method is used three fundamentals apply. The best results are obtained with high-contrast subjects containing bright highlights against dark shadow areas; side- or back-lighting helps to accentuate contrast and so aids the effect; and diffusion in general lessens as the lens is stopped down, so soft focus works best at medium-to-wide apertures.

The most expensive way of achieving soft focus is with a lens built specially for the job. This works by shifting elements within the make-up of the lens in

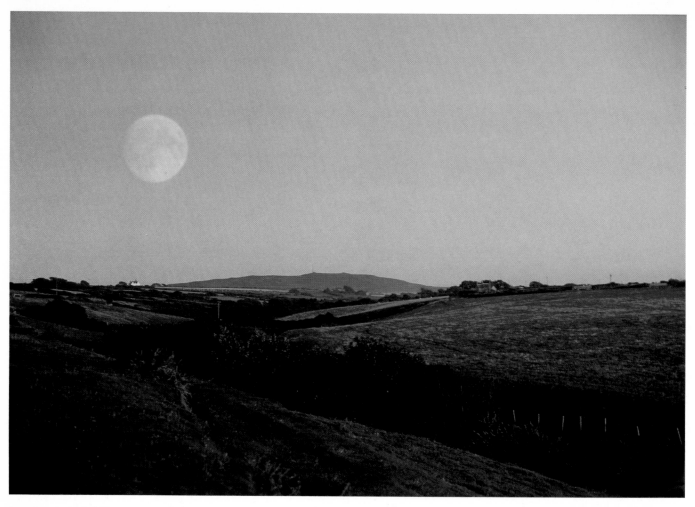

An exposure time of 30 seconds at *f*/5.6 recorded this picture shot by moonlight. The original picture was taken with a standard lens, but with the moon out of shot. Switching to a telephoto lens, the moon was added by means of a double exposure and a shutter speed of ¹⁄₃₀ second at the same aperture.

Opposite, top: details within a landscape, rather than the overall view, often respond well to soft-focus techniques. This shot was made with a special soft-focus lens.

Using an orange filter on infrared colour film produces red foliage and green skies.

order to induce various degrees of aberration. The more the aberration, the softer the image. Several such lenses are available for single-lens reflexes, with which you have the advantage of being able to see the effect through the viewfinder. They usually have a control that offers several different degrees of softness at a couple of different apertures, giving an extremely fine control over the end result.

Perhaps the most popular method of achieving soft focus is with an inexpensive filter designed for the job. A pattern is etched into the filter material to break up the light before it reaches the lens, and the final effect is controlled by the shape of the pattern. Concentric rings etched into the filter produce greater amounts of soft focus at wider apertures than at small; a random array of small dots produces uniform soft focus irrespective of the aperture. Because they break up the light, cross-screen and diffraction-grating filters also give a soft focus effect to some extent.

Soft focus can also be achieved by a number of home-made gadgets. All it needs is some method of breaking up the light before it reaches the lens. One of the most popular do-it-yourself techniques is to smear a very thin layer of petroleum jelly on to a clear filter or piece of optically flat glass, and mount this in front of the lens. The effect works best if the jelly is spread lightly around the edge, allowing a clear spot in the centre. The final effect is of a fairly crisp central image, becoming more and more soft towards the edges of the frame. Other substances that can be coated on to clear glass and held in front of the lens to give a similar effect include hair lacquer sprayed from an aerosol can and allowed to dry, and clear adhesive applied in a series of concentric circles and again allowed to dry.

Black nylon stretched over the front of the lens and fastened in place with an elastic band gives an extremely effective diffused image, particularly suitable for a landscape that evokes the past in some way. Black is the best colour to use with

colour film, since it softens the image without inducing a cast of any sort. Alternatively, a piece of coloured nylon can be used to give an overall tone to the picture. Brown, for instance, will give the finished picture a soft, sepia-like effect. In black-and-white photography, the colour of the material is less important. It is even possible to achieve varying degrees of soft focus without the use of any accessory whatever. All that is needed is your own breath. Breathe lightly on the lens just before you take the picture and then take several exposures as the mist on the glass gradually clears. If you are using a reflex camera, you can see the effect as it happens and shoot accordingly.

Most of the soft-focus techniques described here involve cutting down the light in some way, so exposures are affected. The increase, however, presents few problems, since TTL metering can usually be relied on in this instance to make the necessary corrections automatically.

Distortion

Perhaps the most common way of distorting a landscape is to shoot its reflection in water. The surface of a lake or river will mirror the landscape exactly when it is calm, but ripple the surface with a stick and the image breaks up into a series of wavy lines. A stone thrown into the centre of the image produces circular ripples that spread to the edges of the picture area as you watch. Surfaces other than water can equally reflect and distort the image. Look for reflections in everything from plate-glass windows to the curved chrome areas of car bodies (useful for producing a fisheye type of shot), even in sheets of pliable plastic that you can carry to the locations specifically for the purpose. The glossy black variety often used to line dustbins can be used to effect, but a better medium for this technique is a sheet of mirror plastic.

Distortion can also be induced by photographing *through* some material. Sheets of patterned glass, the sides and bottoms of bottles, drinking tumblers – all are useful accessories for the landscape photographer keen to give his pictures a different look. In general, the closer the camera is to the distorting medium, the further the subject must be from the other side for a recognisable picture. For landscape photography, then, whose point of interest is invariably at infinity, the accessory used for distortion should be held close to the camera lens. Increases in exposure can be taken care of by TTL metering.

Infrared

Infrared film, as its name implies, is sensitive to wavelengths beyond the visible red of the spectrum and into the invisible infrared. It is available in two different emulsions, one for mono photography, the other for colour. While the results from each are different, much of the theory behind the two types is similar. Neither has good keeping properties; also, because infrared rays focus at a different point to the visible light rays, focusing can be a problem. The latter is taken care of by the infrared focusing mark found in the shape of a small red dot on the focusing scale of most modern cameras. Once focused on the subject, the lens barrel must be rotated so that the appropriate distance figure on the scale is moved away from the traditional mark and set against the infrared position. Natural daylight contains infrared, so the film works well with landscapes.

As well as being sensitive to infrared, the film is also sensitive to some extent to blue light. Therefore, for optimum results, filters should be used. With the mono emulsion a deep red filter will take out the blue, leaving infrared to predominantly affect the emulsion. Vegetation like grass and leaves reflects more infrared than visible light, so in the final picture it records as white with the mono emulsion. Skies appear extra dark. Contrast is increased and haze is reduced to an absolute minimum. Accurate speed ratings are not possible with infrared film, but recommendations are given with the film; when these are followed, together with some intelligent bracketing, perfectly acceptable results will be obtained. In dull weather

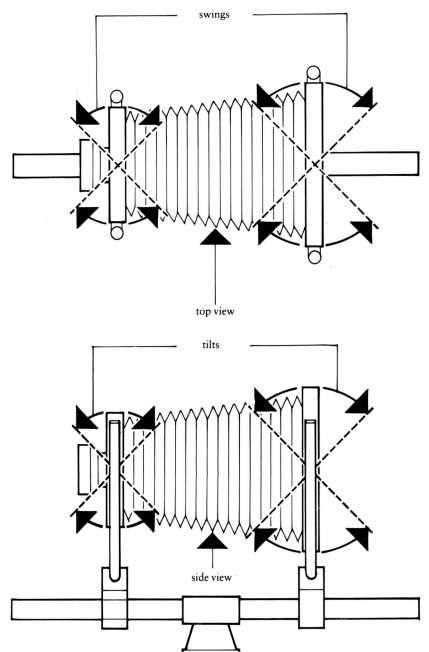

swings

top view

tilts

side view

it is advisable to open up one stop since such conditions lead to a drop in the ratio of infrared to visible light.

The mono film is available from Kodak in 35 mm cassettes and sheet form, and can be processed in standard developers and fixers. Some plastic developing tanks, however, might leak infrared and so fog the film. To prevent that, wrap the tank in a sheet of cooking foil, shiny side out.

When you switch to the colour version of the film, really unusual results start to appear. Used without any filtration the image will take on a strong blue cast, while skies will record as magenta. Used with a yellow filter, reds will record as yellow, green foliage will take on a magenta cast and skies will show as blue. A green filter weakens the strength of that blue and foliage becomes more purple. Orange and red filters give perhaps the most striking effects: foliage turns orange, blue skies turn green and white clouds stand out by contrast in yellow. The colour emulsion is also available from Kodak, as an Ektachrome emulsion. One drawback (at least at the time of writing) is that the film must be processed in the now outdated E4 process, rather than the current E6 chemicals, and few laboratories still undertake the work. Kits are, however, available for home-processing the film.

Camera movements
An elementary form of camera movement can be obtained with a medium-format or 35 mm camera by use of a perspective-control lens. For far more versatility, however, a technical camera must be used. Most of these allow the lens panel and the film back to be swung or tilted in different directions to achieve certain specific effects. Here's what each movement does.

Swing is a movement of either the lens or the back panel about a central axis, either to the left or to the right. Swinging the back alters the shape; swinging the front alters the focus. **Tilt** is a similar movement of each panel, but instead of movement

119

being left or right about a vertical axis, it is about a horizontal axis at right angles to the previous one. Shape and focus of the image are again affected. **Shift** is a movement of either panel to the left or right, the two panels remaining parallel with one another. The movement shifts the subject to the left or right of the frame relative to other objects in front or behind. **Rise and fall** is similar, but in an up and down direction rather than left and right. The subject's position in the frame is again affected.

How these movements can be of use to the landscape photographer is best shown by a working example. Let us suppose you are trying to photograph a landscape whose main point of interest is a tree in the middle distance, but the picture is ruined by a concrete post in the foreground: from the position at which you wish to shoot, the post obstructs the view of the tree. The simplest solution would be to move the camera to the left or right, thus eliminating the post. But let us

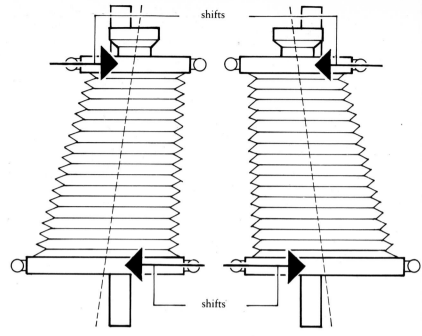

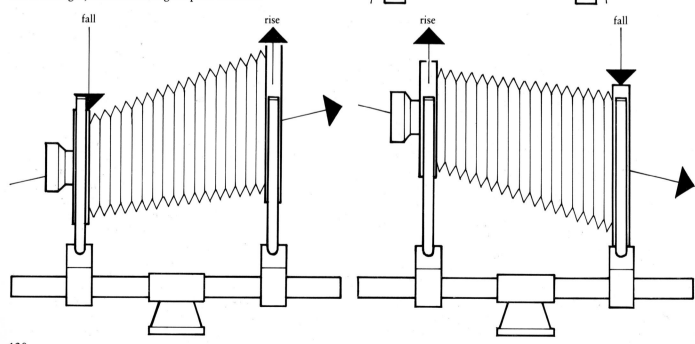

Camera movements and shift lenses can be used to correct verticals when you are shooting urban landscapes. The left-hand picture was shot with the camera tilted, thus allowing the verticals to converge. The right-hand picture was shot with a shift lens on a straightened camera.

further suppose that this is impossible, either because your chosen position is the optimum one of composition or because you cannot move owing to some obstruction at the camera position. The problems could be resolved by the use of camera movements. If the lens panel is shifted left and the back panel shifted right, the result could easily be a view of the tree as you originally visualised it, but with the post moved out of the frame.

Panoramic pictures

Somehow photographs have come to be accepted as having to fall into a 1:1½ ratio. But this isn't the way we actually see. The field of view covered by the human eye is more like 1:2½, a shape that is particularly suitable for landscape photographs. There are several ways of producing panoramic pictures of this ratio, and even wider ones.

Perhaps the easiest and least expensive method is to take a number of prints, either colour or mono, and then join them to make one big panoramic picture.

To do so, first position your camera on a firm tripod, making sure that it is absolutely level. The scene is then lined up in the viewfinder and several pictures are taken, panning the camera between each so that a small area on one side of each picture is repeated on the opposite side of the next. Developing and printing are carried out as normal, the prints are trimmed with a sharp knife or scalpel, and they are matched side by side to make one extra-wide picture. The prints should be butted together, never overlapped, and the overall effect can be improved if, instead of trimming each print straight along one side, the knife is used to carefully follow natural boundaries such as roads or fences in each print.

Panoramic pictures can also be produced by special cameras. There are three basic types. In the first, the camera actually revolves on a handle at the moment of exposure. As it does so, the film also moves across a linear shutter inside, so that the picture is exposed through its thin slit along an extra-wide length. Apertures on the camera follow the standard notation, but shutter speeds are adjusted before the film is loaded by changing the width of the slit in the linear shutter. The picture ratio is up to 1:6½. In the second type of panoramic camera, the camera and the film remain stationary but the lens pivots about a central axis at the moment of exposure, exposing the scene, again through a slit behind its rear element, onto a curved film plane. Apertures are controlled in the conventional way, and shutter speeds vary with the speed of the lens movement. Pictures are in a 1:2½ ratio. Some distortion is inevitable, as objects in the centre of the picture area appear larger than those at the sides. No distortion is evident in the third type of panoramic camera. This takes the form of an extra-wide body that takes 120 or 220 rollfilm, but with a lens designed as wide-angle for a much larger format of 20×25 cm. The film effectively takes a panoramic bite out of the centre of this format, giving extra width while retaining a standard depth. The result is a picture whose ratio is around 1:3.

121

Special lenses also produce the effect. A normal wide-angle or extra-wide-angle lens gives more width to a picture, but also includes more depth. A picture taken with one of these and then cropped top and bottom gives a suitable panoramic effect. A better way of using lenses for the effect, however, is to use an anamorphic. This has two focal lengths, each at right angles to the other. The image of a picture taken with such a lens registers as a normal depth but with its width 'squeezed' laterally. A print made from such a negative, in an enlarger equipped with another or the same anamorphic turned at right angles, keeps the width correct while 'squeezing' its depth. The result is a panoramic format which, according to the lens in use, can give different ratios of as much as 1:3. Anamorphic lenses are available as interchangeable replacements for normal lenses, but are more often seen as auxiliaries, designed to screw into the filter thread of a standard lens. They can also be used on projectors to make panoramic pictures from 'squeezed' transparencies.

1

All the special techniques described so far in this chapter are involved at the taking stage. Space does not permit more detail, but those interested in learning more about these and other camera techniques are recommended to read *Special effects in the camera* which, like this book, is published in the Photographer's Library series by Focal Press.

Diffusion in the darkroom
From taking pictures we move to making them in the darkroom, and here too a number of different special techniques can be used to enhance your landscapes. Diffusion, or soft focus, can be added to a picture at the printing stage by methods very similar to those already covered. Special lenses, filters and various do-it-yourself soft-focus devices can be used on the enlarger lens in much the same way as on a camera lens. The results, however, show one major difference. The soft-focus effect is the result of highlights spreading into the shadow areas, but at the printing stage, when your 'subject' is actually a negative, the highlights *are* the shadow

2

122

Three pictures that show how clouds can be added to a landscape. *Nigel Skelsey.*

1 A straight print of the negative shows a cloudless sky.

2 With the printing exposure adjusted for the sky, the foreground prints too dark.

3 With the foreground masked, two different exposure times can be given to the same print, thus recording clouds and foreground satisfactorily.

areas. Therefore a soft-focus print that has been made by printing a normally sharp negative through some form of diffuser shows shadow areas expanding into highlights, rather than the other way round. The result is the same whether you are printing in colour or monochrome.

Masking

Another common darkroom dodge that is very popular with landscape workers is masking a mono print to add a more interesting sky to an otherwise

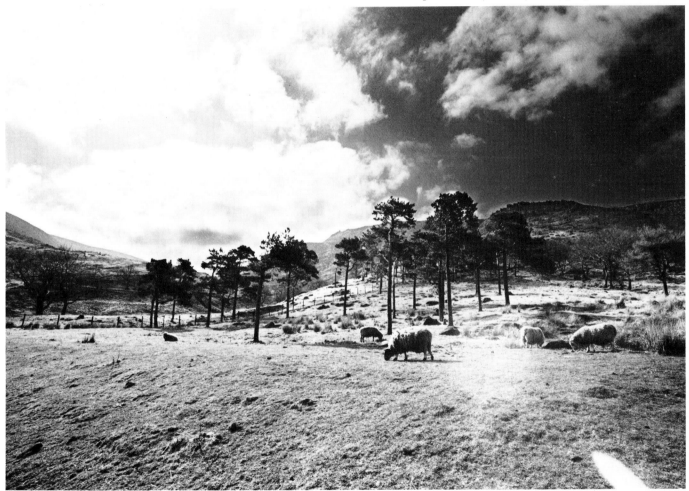

3

blank area. This can be achieved either by using one negative and giving extra exposure for the sky area that has been burnt out by overexposure, or by combining two completely different negatives. The latter is the better method, since it does not involve printing from a grossly overexposed negative, but in choosing the second negative you must take care to match direction of light in the two shots, otherwise the added sky will look totally false.

Combining the two is fairly straightforward. First the correct exposure for each negative is ascertained in the usual way, with an enlarging meter or simple test strip, and the times noted. The landscape negative is then enlarged on to a sheet of plain card and an outline of its horizon drawn on the card. This is then cut carefully along the drawn line to make a mask. The landscape is enlarged on to printing paper in the normal way. Since the sky area is black on the negative, and therefore printing white, no masking is needed at this stage. The landscape negative is then removed from the enlarger and replaced by the chosen sky negative. The lower half of the mask is placed over the printing paper to shield the latent image of the landscape from the enlarger's light, and the second exposure is made. The mask should not be laid directly on to the printing paper, but held a few inches above its surface and moved slightly during the exposure. (If the same negative is being used for the two exposures, it follows that there is no need to change negatives. Masking, however, is carried out in the same way during the second exposure.) The paper is developed and fixed in the normal way.

Texture screens

A texture screen is a small piece of film, the same size as your negative and with a pattern printed on it. The pattern can take many different forms: concentric rings, the crazed look of a concrete surface, the texture of cloth, even the pattern of reticulation. The screen is simply placed in contact with the negative, black and white or colour, and a

Texture screens are sandwiched with negatives in the enlarger to produce their effect. These two pictures were printed with and without a screen.

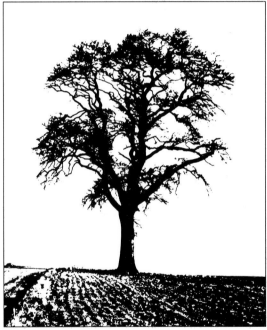

Lith film, when processed correctly, records only blacks and whites, eliminating all intermediate shades of grey.

print is made in the usual way from the sandwich. The resulting print shows the picture combined with the pattern of the screen.

Line film

Line or lith film is one which, when used with the right developer, records only highlights and shadow areas with no intermediate tones. A negative made on lith film and then printed in the normal way displays only deep blacks and pure whites, with no shades of grey between. The film can be used directly in the camera, but it is better used in the darkroom, where any ordinary negative or even a colour slide can be used to produce a new image, either by contact printing or by enlarging on to the lith film in a similar way to normal printing. The image so produced can then be reprinted straight or used to make a further derivation.

Enlarging a positive transparency on to a sheet of lith film will obviously make a negative first time. Using a negative to start with will produce a lith positive from which a new negative can be made on a further sheet of lith film. Because the emulsion is orthochromatic, it can be used in a red safelight. For landscapes, the effect works best on subjects that are dominated by strong lines such as stark winter trees against a blank sky.

Relief effects

Relief pictures differ according to the way they are printed. On soft paper, the result is an image composed almost entirely of grey tones; on a higher-contrast paper, the result could be only the harsh outlines of the subject. The method of achieving the effect is very simple. A same-size positive is first made from your negative by contact-printing it with a new piece of film. The two are placed together so that the dark areas of one cancel out the light areas of the other, and then the two pieces are shifted *very slightly* out of register. The print is made from this sandwich. The effect works at its best if you start with a slightly overexposed negative. The intermediate positive made from that must be of high contrast; if ordinary film does not give the required result, lith film can be used in its place.

Solarisation

The frustrating, but also the beautiful, part of solarisation is the fact that no two attempts ever produce the same result. The technique involves the partial reversal of an image so that the final picture shows a subject that is partly positive and partly negative. The technique can be carried out on original film or on paper at the print stage. It works better on film than on paper, so for reasons of

This 360-degree panoramic landscape was taken with a special camera that revolves on its base at the moment of exposure.

economy it is best to start with a normal negative and produce a new image on lith film from which to work. The image you are solarising, and from which you will make the final print, is of course a positive rather than a negative, but since the process involves reversal this does not matter too much. For the purist, a further negative can be made from the derived positive before starting the solarisation process.

At whichever point you decide to solarise the image, the process is fairly straightforward. Place the film in developer as normal, but develop only for one-third its normal time. Remove the film from the developer and expose it to a uniform white light for no more than a few seconds. Replace the film in the developer and continue development for the further two-thirds of time. Wash and fix in the normal way.

The image you have now produced should be solarised, and a print can be made from it in the normal way. In all probability, however, the image will be very dense and so will need an extra-long exposure time under the enlarger. Alternatively, instead of making a print at this stage, you can make a new negative on line film and print from that, or even solarise that result even further.

Just as with the special effects in the camera, this section on darkroom effects is, of necessity in a book such as this, very brief. Those interested in taking these matters further are recommended to read one of the many books devoted to the subject. *Creative Photographic Printing Methods*, published by Focal Press, is one that deals with the techniques in the necessary detail.

When you have learnt all the rules of composition, learn how to break them. Here's a picture that works well despite the unconventional placing of the various elements. *John Russell.*

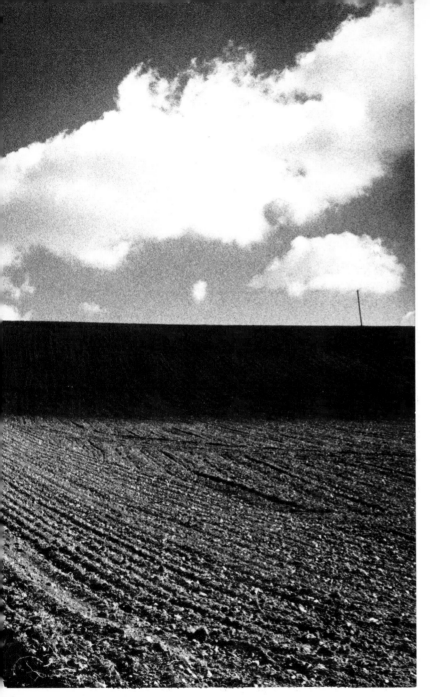

The end product

To some, the act of taking a picture and then perhaps making a print in the darkroom is an end in itself. Once the picture has been produced, the photographer feels he has come to the end of the line; the next step is to take another picture. If you find yourself feeling that way, you are missing out on one of the most important aspects of photography. Photographs should be *seen*. They should be displayed, put to some specific use, entered into contests maybe, even sold for a profit. Because landscape photography is such a wide-ranging subject, it lends itself easily to many different end products.

Mounting and framing prints
Landscapes are among the most popular subjects for general room decoration. For that you need prints, and for the best effect they should be presented in a neat and interesting way. They need first to be mounted, and then framed. There are several different ways of mounting prints; in the end, the one chosen is very much down to the taste of the individual. Here are some of the options. Mounts need not be seen at all: the print can be mounted flush on thick card or even wood, used only to keep the photograph stiff and prevent damage. When carrying out the actual mounting procedure, on card in this case, it is best to use a mount that is marginally smaller than the print and then to trim all four sides slightly once it is stuck down. This practice is of course inadvisable if you are mounting on wood.

If you are using a mount that is larger than the print, the most conventional method is to stick the picture down in the centre with equal space on all sides, or possibly slightly higher than centre on the vertical axis so that, although equal space is seen on each side, there is slightly more at the base than at the top. If you decide to add some kind of

ornamentation to the mount, the rule is to keep it simple. A thin black line drawn a centimetre or so from the edges of the picture can enhance the subject, but a thick line might start to overpower the picture itself. If you do decide on this procedure, use an artist's pen, never a ball-point. The latter is far too much inclined to smudge at the corners where two lines meet.

White mounts are probably most popular, with black coming a close second. Grey can work well with the right picture, provided you take care that the colour doesn't overpower the subject and therefore give it a drab look. If coloured mounts are used, they should complement the picture and preferably be used with colour prints, rather than black and white. Dark shades work best, but even with colour prints black or white mounts are often preferable.

If you decide to go for the more unconventional approach, you can mount your picture off-centre, but make sure you have a definite reason for doing so. There is, for instance, little point in mounting a very conventional landscape photograph in a totally unconventional way. But if your subject is perhaps a little more bizarre it might well benefit from a different way of mounting. When you come to stick the picture down, think in terms of the picture composition rules covered earlier in this book. The photograph can be placed on a third in a mount, in just the way the subject might originally have been placed in the picture. And, if there is a sense of direction in the picture, it can be enhanced by allowing more space on the side of the mount into which the subject is 'moving' than on the other. Don't be afraid to stray from the traditional shape for mounts. Just as pictures can be different shapes, so mounts can be cut to match them. In the same way, the prints themselves do not have to be conventionally shaped. They can be cut in ovals, diamonds, circles etc., and still be mounted on square or oblong backgrounds.

Mounting prints is a lot like taking the pictures in

the first place. If you are going to be unconventional, you must have a reason. If you have an eye for a picture, you should have the right eye for mounting. Don't be afraid to experiment, but remember one important rule: the mount is there to complement the picture, not to compete with it.

There are various ways of securing the print to the mount. Perhaps the simplest is to stick the print down with some kind of rubber-based adhesive. The gum is spread thinly and evenly on both the print and the mount and then left for a few minutes to dry slightly. The two are then placed together and pressed evenly over the surface with a clean cloth. When fully dry, stray particles of gum can easily be rubbed away with a clean finger. In place of rubber-based adhesive, a dry mountant can also be used. This comes in an aerosol can which is used to spray the adhesive on to the surfaces. Again they are allowed to dry slightly before pressing together. Dry-mounting tissue is yet another method. This takes the form of a thin piece of tissue paper, coated on each side with gum plus a layer of wax. The tissue is placed between the print and the mount and heat is applied to the surface, causing the wax to melt and the gum to bond the two surfaces together. The heat can be applied by way of a domestic iron, pressed through a sheet of greaseproof paper on to the surface of the print, but a more satisfactory method is to use a dry-mounting press that delivers heat and pressure in one action.

These methods of mounting will work equally well on card or wood, but you might also consider the use of commercially available wood-block mounts, designed and made to standard printing-paper size. With these, the necessary adhesive is already applied and protected by protective paper. The paper is removed and the print pressed down evenly on to the surface of the wood.

A different method of mounting is to cut an aperture in the card with a sharp knife or scalpel

and then to mount the print *behind* the card itself, to be seen through the cut-out frame. This method is particularly effective when the finished product is to be framed. One rule of mounting applies equally to framing: make sure the frame complements the picture, rather than competing with it. Keep to simple, rather than elaborate, patterns. When you buy a frame, look for one that is larger than the print. While flush-mounted pictures work well on their own, they rarely look good in frames. A space is needed between the photograph and the frame edges for the best effect. When you come to hang the print remember that glass is highly reflective, so do not hang it directly opposite a light source that will be reflected by the glass and make the print difficult to view. Stay clear too of hanging prints in direct sunlight, which will cause them to fade, especially quickly in the case of colour prints.

Mounting and presenting slides

There are three popular types of slide mount: cardboard, plastic and glass. The simplest to use is the card type. In that, the transparency is simply cut from its strip and placed in position, the mount is folded over and the two sides are pressed firmly together. Card mounts are cheap and particularly convenient for writing name, exposure details etc. directly on to the edges. Plastic mounts are more permanent, holding the slide in position in one half, while the other is pressed into position with a firm 'click'. Glass mounts are similar, with the addition of an ultra-thin sheet of glass on each side of the mount to protect your slide.

Of the three, glass mounts offer the best protection and are well suited to the photographer who wants to do no more than project his slides, either as a simple showing of the pictures or as a more ambitious audio-visual presentation. If, however, you are thinking of selling or submitting your slides for publication, glass mounts are far from ideal. For one thing, they tend to get broken in the post; for another, publishers don't like them, since the printing process requires the transparency to be removed from its mount. If publication is your aim,

you really cannot beat the good old-fashioned card mount.

Whatever type of mount you use, you must have a method of indicating which way round the slide is intended to be viewed. There are eight different ways of looking at a slide and only one of them is correct. To get it right every time, the slide must be spotted. This means placing a spot, either in the form of a commercially available self-adhesive disc or by the simple means of a pen or pencil, in the bottom left-hand corner of the slide mount when the picture is the correct way round as viewed against a light. The spot then falls in the top right-hand corner when the slide is projected, since slides must be placed into a projector upside-down.

Landscape photography makes a perfect subject for a slide show, but if you are selecting pictures for projection be strict with yourself. Choose only the best and don't fall into the trap of showing several different views of the same subject or, worse still, the same picture shot at different exposures. Nothing is better guaranteed to bore your audience. Keep to your best slides and keep the show short. When putting the show together, it is good practice to place similarly-toned slides next to each other. Don't jump from a high-key picture to a low-key one and then back again, because sudden changes of light intensity on the screen can hurt the eyes. Remember, the best slide show is the one that leaves the audience wanting more.

If you see the end product of your landscape photography more as a commercial enterprise, you will need some way of presenting slides to clients. For this, plastic filing sheets are available, designed to fit into a standard filing-cabinet drawer or ring binder and having a set number of pockets, each designed to take a slide. Different sizes of pocket are available for different formats. Some have light-diffusing plastic backs to make viewing easy, and may also feature a plastic oversheet for extra protection. A variation that creates even better presentation takes the form of sheets of black card

which have apertures cut for each slide fitted and which can be slipped into sleeves of clear acetate. When viewed, only the slides themselves are seen, surrounded by black. Sheets are available to take single slides of different formats, and also to take a set number of transparencies either in or out of their usual mounts.

Selling landscapes

Landscape photography has a universal appeal. Its subject is the sort of thing that people like to hang on their walls. Couple this with the fact that photography these days is becoming more accepted as suitable for interior decoration, and you begin to see the strong possibility of selling your pictures to private homes. Don't be too ambitious to start with. Just make large prints of two or three of what you consider to be your best subjects and show them around. Very often a small gimmick can make all the difference in this market; for instance, a picture of an old building that has been sepia-toned and maybe printed through a vignetting device might appeal to the non-photographer customer more than a straight print. Try your luck in art shops, too, offering limited numbers of each print. There has never been a time when photography has been better accepted as art, and if you have the right sort of pictures there is no reason why you shouldn't cash in on the fact.

There is also a market for landscapes among magazines. What you must bear in mind, however, is that each magazine has its own style and will only buy pictures that conform to that style. So take a look through a lot of magazines and see what they are buying. Learn to recognize exactly what they use and then send them more of the same. Some magazines, for instance, might use a straight full page, showing nothing more than a beautiful landscape for its own sake; others might be looking more for oddities such as unusual features in an otherwise traditional landscape.

Perhaps the best magazine market for your landscape photography is the photo press. There are more photographic magazines in Britain, for instance, than in any other country in the world and they are all looking for material. Very few, however, are looking for straight picture portfolios. It *is* possible to sell a set of pictures just for their own sake, but the market is limited and the standard is high. For a more positive chance of a sale, you are better off submitting either pictures with an article, explaining techniques, or sets of pictures which the magazine might file and eventually use to illustrate someone else's words. Either way, black and white always stands a better chance of success than colour, because of the limited amount of colour editorial space available in most magazines and because editors are loath to keep colour on a picture file for what could be years at a time.

Most photographic magazines today are looking for examples of photographic technique, so your pictures will stand their best chance of success if they have something *photographic* to demonstrate. That could mean, perhaps, the use of certain types of filter, the way light affects pictures, or maybe the use of different lenses. Photographic magazine editors especially like pictures that show comparisons. With this market in mind, shoot examples of the way different techniques affect the same subject. A good example might be the way a landscape with strong foreground interest can be shot with the foreground sharp and the background blurred, with the background sharp and the foreground blurred or with the whole scene sharp, thus illustrating the effects of depth of field and hyperfocal distances.

Photographic magazines also run contests, and your pictures can be used for these. The bad news is that most photo contests overflow with landscape pictures as entries; the good news is that few of them are very good. Any judge will tell you that the average entry is of a bland landscape with no foreground interest, shot with little thought for composition and under dull lighting conditions. Send them a picture shot under the influence of

what you have learnt in this book and you could be well on your way to success. And of course photographic magazines are not the only organisers of photo contests. There are contests all around you, in non-photographic magazines, in newspapers, on the sides of cereal packets, in travel brochures, and run by bodies like town councils and large photographic companies. If the entries in photo-magazine contests are of a low standard, think what these others must be like! Obey a few simple rules and you could put your pictures right up there among the winners.

When you are sending pictures to a magazine, either for file use or for a contest, always make sure your presentation is as simple and effective as possible. Prints should be packed with stiff card on each side to prevent them becoming bent in the post; transparencies are best submitted in the plastic wallets mentioned earlier. Put your name on the back of every print and on each slide mount, include details on a separate sheet of paper, and

keep your letter brief and to the point. Unless the magazine makes a point of stating otherwise, always deal direct with the editor and *always* include a stamped addressed envelope for the return of your work.

The greetings-card and calendar markets are wide open for landscape photography. They probably use more landscapes than any other single subject, but the quality demanded is the very highest. A few years ago, these markets would consider only large-format transparencies. These days most of them will settle for a minimum of 6 × 6 cm, and a very few will even consider 35 mm, but you will stand the best chance of selling to this market if you can use the largest-format camera available to you. The names and addresses of companies specialising in these markets can be found in freelance writing and photography handbooks, but make sure your technique is one hundred per cent perfect before you even think of submitting to them.

Often it's the corniest of pictures that sell. This is the type of picture (originally shot in colour) that might be bought by a calendar company.

Picture agents

Using an agent is often a good way of selling your pictures if you have the right kind of work and, just as important, the right attitude. A picture agent is not in business to sell all those pictures that you couldn't sell yourself. He doesn't want your second-hand work, he wants your best. And he wants lots of it. An initial submission to a picture agent is usually considered to be a minimum of 300 pictures. If the agent likes what he sees, he will keep a selection on file and, hopefully, sell some of them on your behalf. His commission will usually be around 50 per cent, which might sound a lot but which becomes more than reasonable when you consider he might sell one picture two or three times for you. Also, because of his position, he will be able to negotiate higher rates than you might on your own. Different agencies specialise in different subjects and, just as with any market, you must find the agent that is right for your type of work. Agents are particularly useful for getting at markets that the private freelance might never break into: jigsaw puzzles, chocolate boxes etc., all need a supply of picturesque landscapes. Lists of agents and their requirements can be found in various freelance photographers' handbooks.

Exhibitions

One of the greatest joys of photography is to see your work on show in an exhibition of top work, and landscape photography is a subject that lends itself particularly well to this side of the hobby. There are many different types of exhibition, but they break down into two distinct areas: exhibitions organised (usually on an annual basis) to promote good photography, and those organised by a recognised photographic gallery, where you stand a chance of selling your work.

Exhibitions of the first type can be small and local or large and national. They can even be run on an international basis. The smallest are the exhibitions organised by photographic societies and camera clubs up and down the country. Most of the best clubs hold annual shows of members' work, and joining one of these will give you the chance of comparing your pictures with those of fellow members. If the club is small, there is a good chance that every picture put forward for the exhibition will be hung. With larger clubs, there will be a selection committee to choose only the best. From clubs you can progress to federation exhibitions in which your work might represent your club, and then on to national exhibitions.

Apart from these club-related shows there are also a lot of national and international exhibitions, both in the UK and overseas, to which you can submit your pictures. Some exhibitions have themes, others are for general photography, but in all of them the quality is high and the acceptance percentage low. If you get your work selected for one of these, you know it's good. Details of entry and venues can usually be found in the news pages of the photo press, and sending a stamped addressed envelope to the organisers will bring you all the details you need to enter: These will differ with individual exhibitions, but a few points are common to all. Prints should always be well-packed and submitted flat. For British exhibitions they should be mounted, but you can usually get away with unmounted prints when sending abroad. You must always submit in good time for the closing date; for overseas shows, that can mean as much as four months in advance if you are sending your pictures surface mail. Sending entry fees abroad is best handled by way of international money orders from your bank.

Exhibitions organised by photographic galleries generally show the work of one photographer or perhaps a small group whose pictures form a common theme. There are a lot of galleries around, but nearly all have long waiting lists. Nevertheless, if you feel your work is up to the required standard, it could pay to make a few visits with portfolios of your work. What you need to show is that your work is varied, comprehensive and of a high enough standard to sustain an entire exhibition. You must, therefore, have a lot of pictures. In the

A black mount on the right subject can enhance the picture tremendously. *John Russell.*

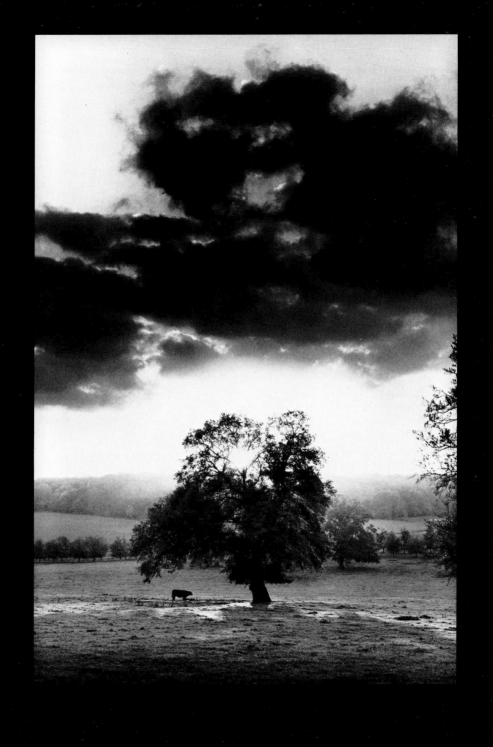

first instance, most gallery directors will be prepared to look at a portfolio of small prints, unmounted and no larger than 20 × 25 cm. This should give a good idea of the exhibition you have in mind. If the gallery is interested, they might ask you to supply around thirty pictures of exhibition size, and from then on, if the gallery is a good one, the organisers will take over, mounting, framing and presenting your pictures in the best possible way. Once the exhibition is under way, you could find that some of the galleries are prepared to sell limited editions of prints on your behalf for quite worthwhile sums.

Distinctions

Yet another use for your landscape pictures is to give you the opportunity of getting a distinction that allows you to put letters after your name. In Britain the most prestigious distinctions are those offered by the Royal Photographic Society, which offers a Licenciateship, Associateship and Fellowship entitling you to put LRPS, ARPS and FRPS respectively after your name. The first step towards getting one of these distinctions is to join the RPS. Membership enquiries should be addressed to the Secretary, Royal Photographic Society, National Centre of Photography, The Octagon, Milsom Street, Bath BA1 1DN. Once you are a member, a stamped addressed envelope will bring you a set of leaflets detailing what is required for each distinction. These will give you far more details than space allows here, but in general you can assume that for the Licentiateship a certain amount of variety in subject matter is called for; at the Associateship and Fellowship level, a more specialised approach is expected. Prints or slides can be submitted, but they will all be viewed by the judges as sets and so a certain amount of continuity is needed between your submitted pictures.

At Licentiate level no particular subject matter is dictated, so the landscape photographer would do well to add other subjects to his submission. It is a different matter for the Associatship and Fellowship. Each is divided into many different sections; landscape photography would fall into the Pictorial Section of each. For the Associateship, the judges look for proof that you can specialise in different aspects of landscape photography. At the Fellowship stage, they would hope to see further proof that you can narrow your specialisation to one particular aspect of the subject: the use of light, for instance.

Distinctions like this won't make you rich, but they will bring you prestige. They will also tell you for certain that your work is of a particularly high standard. The act of shooting a portfolio of pictures, presenting them as perfectly as you know how and submitting them as a set is remarkably good experience. Even if you don't win the chance to put letters after your name, that experience can only make you a better photographer. And, when you come to think about it, that is the end product for which we should all be striving.

Landscape pictures like this have universal appeal. This particular shot has won its author two photo-magazine competitions, has been published in books and magazines world-wide, was part of a winning panel for the Royal Photographic Society's Fellowship distinction, was part of a one-man exhibition in London, and has been accepted for many other international exhibitions. *John Russell.*

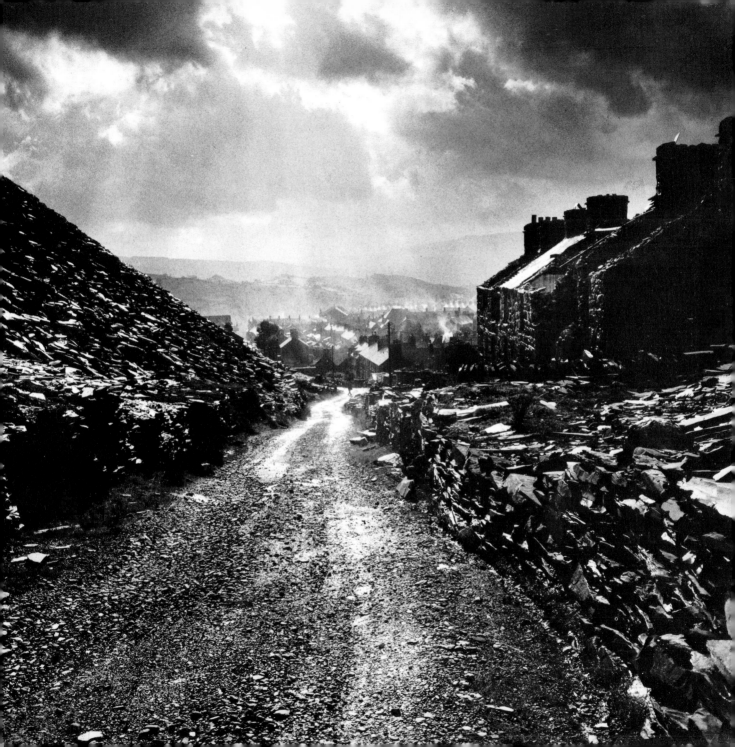

Frank Peeters.

Glossary

Aberration Any deviation from optical perfection in a lens.

Angle of view The largest angle formed between two light rays travelling from the widest perimeters of the subject. In essence, the area covered by a lens of a particular focal length.

Aperture A variable gap behind or between the elements of a lens, adjustable to control the amount of light reaching the film. The size of the gap is measured in *f*-stops, each of which allows through twice or half the light of its neighbour.

Aperture priority A form of camera automation in which the user sets the aperture and the camera selects and sets the correct shutter speed.

Audio visual Slides and music combined for effect, usually by way of a minimum of two projectors, each fitted with a means of fading the image of one slide into the next.

Autofocus A method of automatically focusing a camera lens on a specific area of the picture.

Bellows Flexible material linking the lens panel of a studio camera to the film holder. Usually pleated to facilitate easy movement of one in relation to the other.

Bitumen of Judea A substance used in the earliest form of photography. It remains soft and soluble unless affected by light, a fact that led to its use for making a positive reproduction of an image projected on its surface by a lens.

Bracket To make additional exposures, one stop or less each side of the exposure which is considered to be correct, to allow for inaccuracies in metering.

Camera obscura An artist's device used to project an image on to a surface as an aid to sketching. Used in early experiments in photography in attempts to fix the image so produced.

Centre-weighting Applied to TTL metering, the traditionally most important area of a picture for accurate exposure, and therefore the spot from which the meter has been designed to take its principal reading.

Close-up lens Single-element lens of long focal length which, when coupled with a normal lens, reduces its effective focal length and so allows it to focus closer than normal.

Complementary colour The colour which, when mixed in the right proportions with a given colour, results in white light. The primary colours of light are red, blue and green; their respective complementaries are cyan, yellow and magenta.

Contrast The difference between the lightest and the darkest areas of an image. When the difference is great, the contrast is high; when it is small, the contrast is low.

Contre-jour Another name for back-lighting.

Converging verticals The appearance of convergence with distance of parallel verticals.

Darkslide A flat cover incorporated into a plate or cut-film holder, designed to keep light from the sensitive surface of the emulsion until the moment of exposure.

Depth of field The zone of acceptable sharpness in a picture either side of the point of precise focus. Dependent on aperture, camera-to-subject distance, and focal length of the lens in use.

Element Any one of a number of component lenses, both convex and concave, that make up a compound lens.

Extension tubes Cylinders of various lengths designed to fit between the body and lens of an interchangeable-lens camera, thus allowing closer than normal focusing.

Film-back A detachable back found on medium- and large-format cameras, designed to contain a film plus darkslide and so allow film to be switched part-way through a roll.

Focal length The distance between the centre of a lens and its sharply-focused image when the subject in focus is at infinity. Used to calibrate and identify lenses, and usually measured in millimetres. The longer the focal length, the greater the magnification, and vice versa.

Focal plane The area in a camera occupied by the film at its place of exposure.

Grey card A grey-coloured card which reflects exactly 18 per cent of the light falling on it. Used for measuring exposure.

Guide number A number, variable with the speed of the film in use and applied to individual flashguns to provide a means of determining exposure with that particular gun and film-speed combination. Guide number divided by flash-to-subject distance equals the recommended aperture.

Harris shutter A device containing red, green and blue filters, designed to make an exposure through each on a single frame of film.

High key Term describing a picture composed principally of highlights, with a minimum of shadow area.

Hyperfocal distance The distance between the camera and the nearest point in focus when the lens is set at infinity. With a set aperture and the lens reset to this distance, the image will be sharp from half the hyperfocal distance right through to infinity.

Infinity A point of sufficient distance from a camera lens as to be unaffected by normal focusing. Varies with the focal length in use. The longer the focal length, the further the minimum distance that can be considered as infinity.

Infrared The first wavelength of light past that of visible red, and the first to be invisible to the human eye.

Iris diaphragm A combination of thin metal leaves, designed to move over one another and so produce a circular gap of variable diameter. Used to control the aperture in most conventional lenses.

ISO International Standards Organisation. A scale on which the speed, or sensitivity, of a film is measured.

Latent image A theoretical image, produced by the action of light on certain silver halides, which does not become visible until those halides are treated with a developing agent.

Latitude The degree by which a film can be under- or overexposed without appreciably affecting image quality.

LED Light-emitting diode. An indicator light made from a special semiconductor material which, when attached to a low voltage, will light up with a red or green glow. Used on camera bodies and in viewfinders to indicate exposures or signal functions such as the operation of a delayed-action device or battery check.

Linear shutter A slit through which film can be exposed and whose width controls the effective shutter 'speed'.

Low key Term describing a picture consisting principally of shadow areas, with a minimum of highlights.

Mirror plastic Flexible and highly reflective material, available by the roll in standard widths.

Modelling The degree and contrast of light on a surface that ensures that the subject is recorded on film as a representation of its true shape.

Motor drive An accessory which, when attached to the right camera, automatically winds the film between exposures for either single shots or continuous bursts. The speed of wind is faster than that found in power winds.

Neutral density Various tones of grey used in filters to reduce the intensity of light without affecting its colour.

Orthochromatic Used to describe an emulsion that is not sensitive to red light.

Pan Applied to cameras, movement from side to side while keeping the camera horizontal and following a moving subject.

Parallax The difference in the view seen by the lens and that seen by the viewfinder in a non-reflex camera.

Pentaprism Five-sided prism used in the viewfinder of a single-lens reflex to allow the photographer to view the subject the right way up and right way round.

Power wind An accessory which, when attached to a camera, winds the film between frames. The speed of wind is much slower than that of a motor drive.

Programmed automation A form of camera automation in which the camera selects and sets both shutter speed and aperture for correct exposure.

Rangefinder A mechanical device built into camera viewfinders to facilitate accurate focusing.

Reciprocal Mathematically, a given number divided into one. The reciprocal of 2 is ½.

Reciprocity failure An apparent loss in film speed when extra-long or extra-short exposures are being made. Does not apply at normal shutter speeds between 1 and ¹⁄₁₀₀₀ second.

Reticulation The cracking of a film's emulsion, caused by wide differences in temperatures of processing solutions.

Shading In the darkroom, the holding back of one portion of a picture under the enlarger so that other parts can be given extra exposure.

Shutter A device for controlling the amount of time that film is exposed to light.

Shutter priority A form of camera automation in which the user sets the shutter speed and the camera selects and sets the correct exposure.

SLR Single-lens reflex. A camera whose viewfinder incorporates a system that allows viewing through the taking lens.

Spectrum The range of colours of visible light that combine to make white light. Its colours are red, orange, yellow, green, blue, indigo and violet.

Spotlight A harsh source of light that can be focused on the subject and the width of whose beam can be varied.

Step-down ring An adaptor used between lens and filter to allow a lens of one filter thread to accept filters of a smaller diameter.

Step-up ring An adaptor used between lens and filter to allow a lens of one filter thread to accept filters of a larger diameter.

Stop See aperture.

TLR Twin-lens reflex. A camera with two matched lenses, one for focusing an image on to the film, the other to project a same-size image via an angled mirror on to a hooded ground-glass screen. The view is laterally reversed left to right.

TTL Through the lens. Method of metering built into certain cameras in which the exposure reading is measured directly through the lens.

Wavelength The distance between two corresponding points on successive waves of radiation. Applied to visible light, the red end of the spectrum has a longer wavelength than the violet end.

Zoom lens A lens of variable focal length in which the image remains in focus throughout its range.

Index